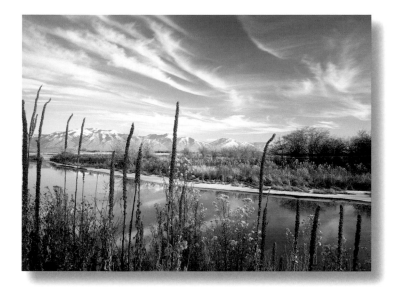

UTAH

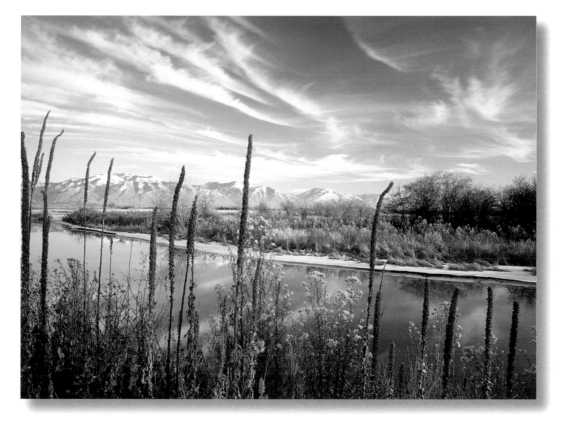

whitecap

Text by Helen Stortini
Edited by Ben D'Andrea
Photo editing by Helen Stortini
Cover and interior design by Steve Penner
Typeset by Helen Stortini

Printed and bound in Canada by Friesens.

Library and Archives Canada Cataloguing in Publication

Stortini, Helen

 Utah/Helen Stortini.

(America series)
ISBN 1-55285-784-0
ISBN 978-1-55285-784-7

 1. Utah—Pictorial works. I. Title. II. Series.

F827.S76 2006 979.2'034'0222 C2006-900327-0

The publisher acknowledges the support of the Government of Canada through the
Book Publishing Industry Development Program (BPIDP), the Canada Council, and the
Province of British Columbia through the Book Publishing Tax Credit.

For more information on the *America* series and other titles by Whitecap Books,
please visit our website at www.whitecap.ca.

From the salt-encrusted shores of Great Salt Lake to the snow-capped peaks of the Uinta Mountains and from the lush farmland of the Fruitway to the world-famous silhouette of Delicate Arch, Utah is filled with some of the earth's most dramatic landscapes.

An outdoor enthusiast's paradise, Utah is home to barren deserts, majestic canyons, lush forests, and soaring mountains. With five National Parks and Wasatch Mountain's Olympic-class skiing, this diverse state has something for everyone. Visitors travel from around the world to hike through the brilliant red sandstone formations of the southwest and hit the slopes with the "best snow on earth" in the north.

Aptly named the "Beehive State," Utah was founded by industrious and persevering pioneers. Faced with religious persecution, Brigham Young led a group of Mormon settlers from Nauvoo, Illinois, to what is now Salt Lake City. The group traveled almost 1,300 miles in search of a new home, enduring harsh conditions across five states. Between 1847 and 1869, roughly 70,000 Mormons followed in their footsteps to carve out an existence in Utah's rugged wilderness. Their efforts resulted in numerous thriving communities across the state. Today, more than 60 percent of Utah belongs to the Church of Jesus Christ of Latter-day Saints. Utah is filled with historic sites, such as restored communities and preserved homesteads, that pay tribute to the efforts of these early pioneers.

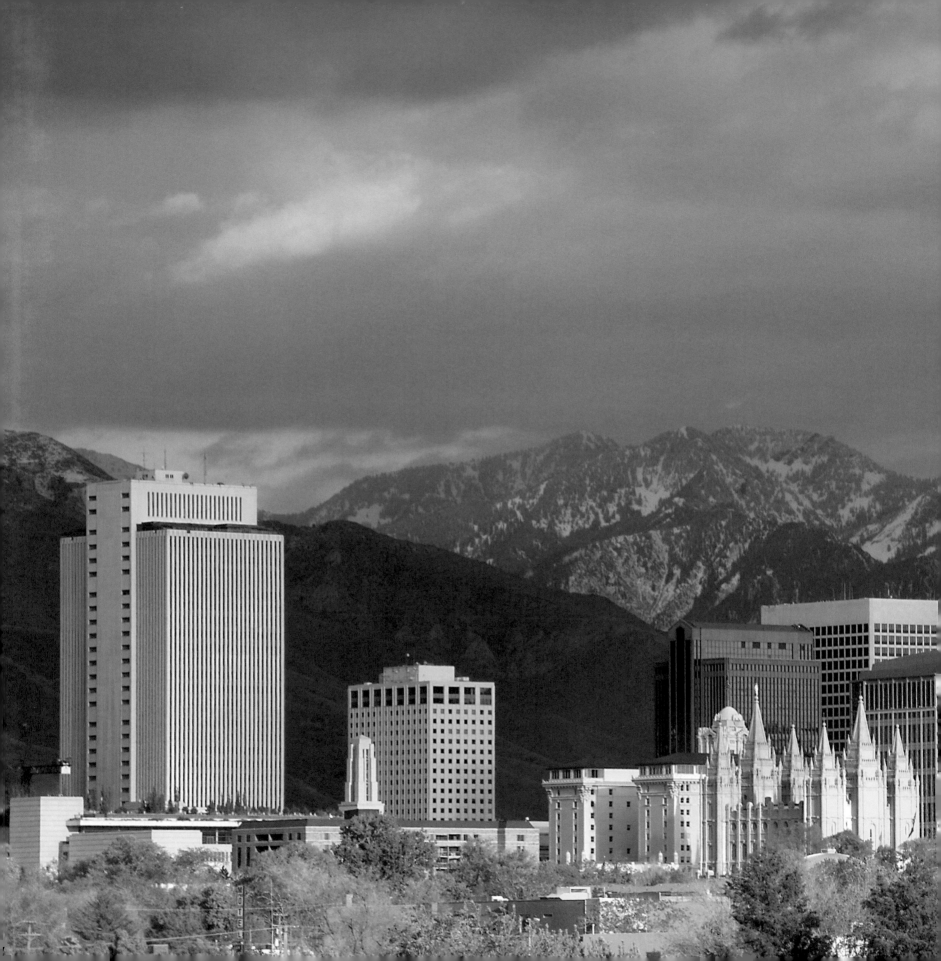

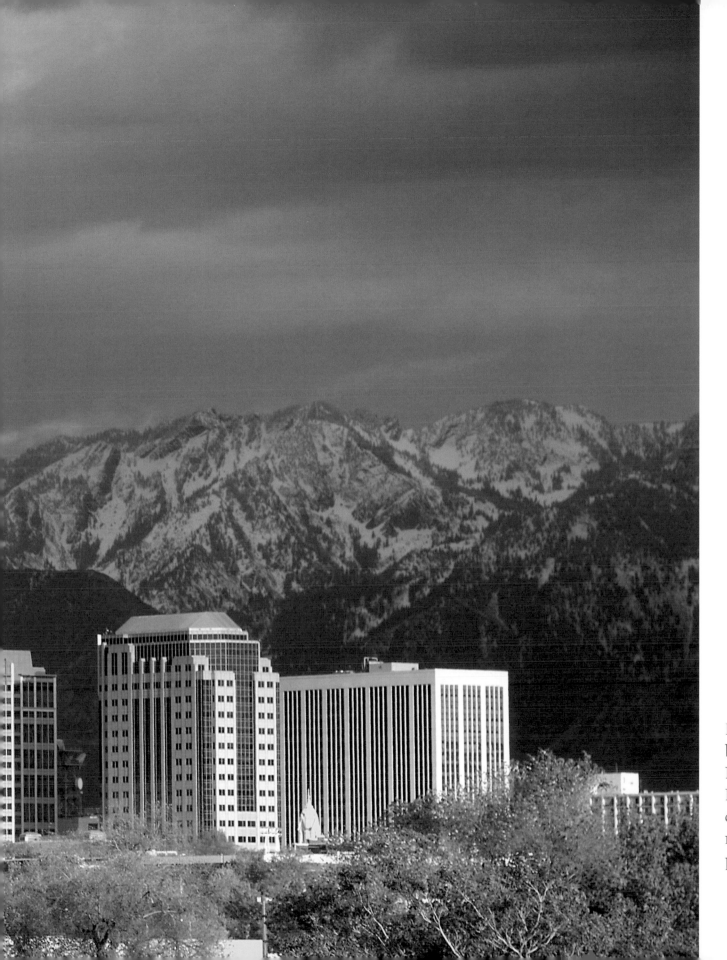

Nestled at the base of the Wasatch Mountains, Salt Lake City—Utah's capital—is home to more than 180,000 people.

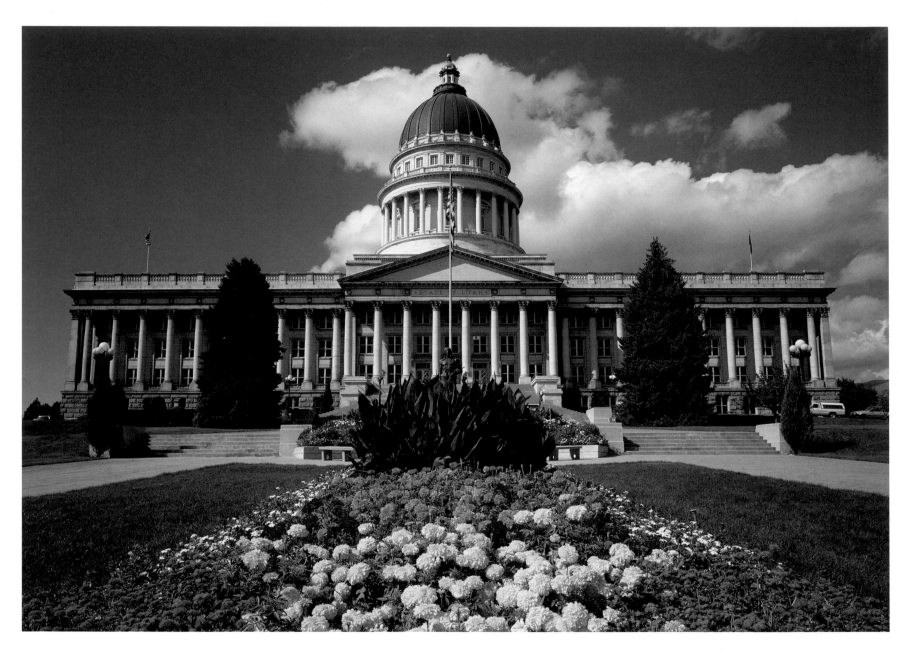

Located on Capitol Hill in Salt Lake City, the Utah State Capitol was completed in 1916. Constructed with granite and topped with a copper dome, the building features more than 50 Corinthian columns.

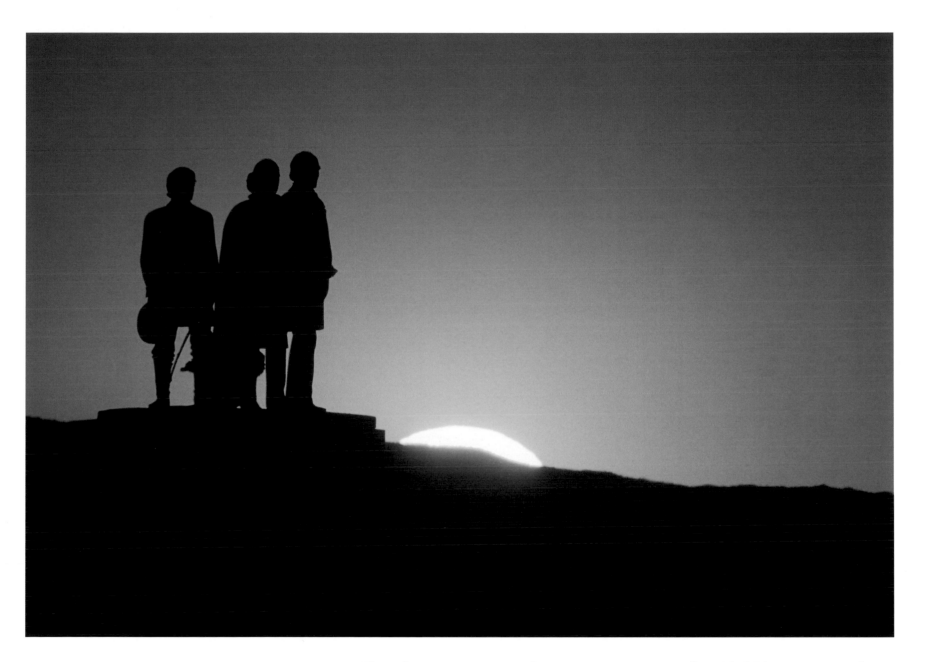

The Place Heritage Park is a monument to the 70,000 pioneers who traveled thousands of miles to settle in Utah's desert. The monument is home to a historical representation of life in Utah from 1847 to 1869, complete with log cabins and covered wagons.

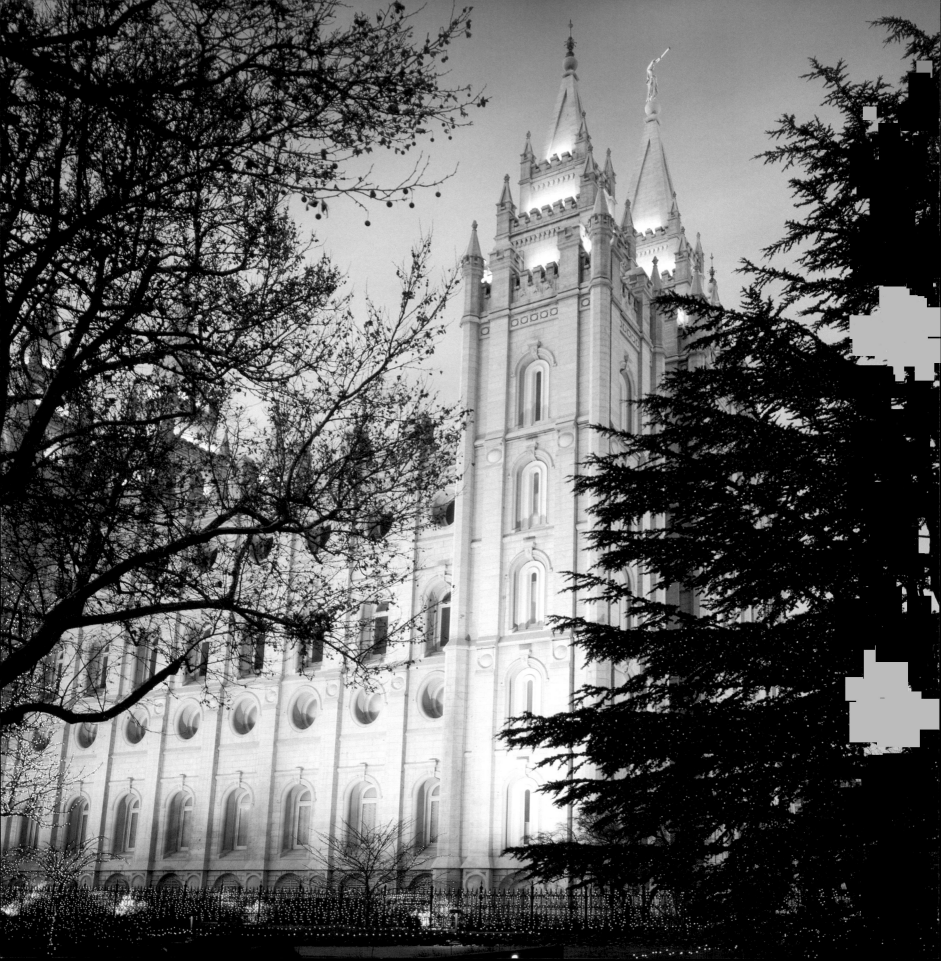

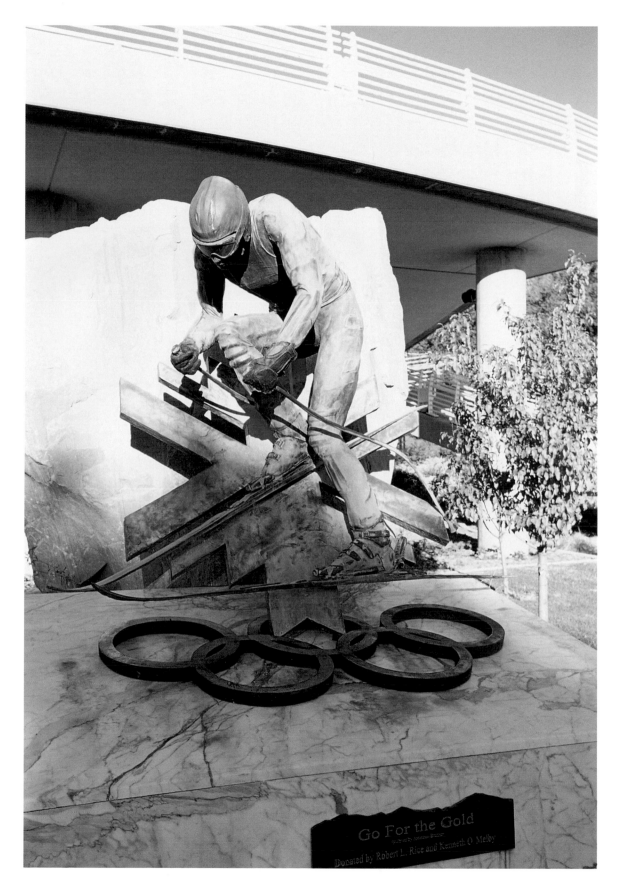

Go For the Gold

Donated by Robert L. Rice and Kenneth O. Melby

FACING PAGE
More than 5 million people visit Temple Square each year, Salt Lake City's biggest tourist attraction and the headquarters of the Church of Jesus Christ of Latter-day Saints. Mormon pioneers took 40 years to complete the temple.

In 2002, the world turned its attention to Salt Lake City as it hosted the 19th Olympic Winter Games.

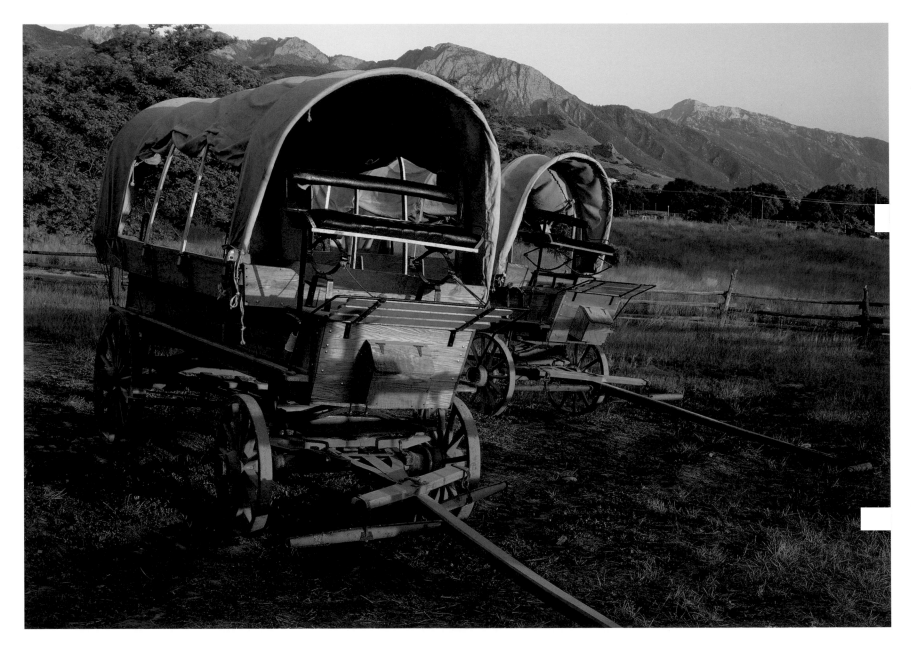

More than 80,000 Mormon pioneers traveled along what is now a national park—the Mormon Pioneer Trail—in order to escape religious persecution. Starting in Illinois, the trail travels through five states and covers about 1,300 miles.

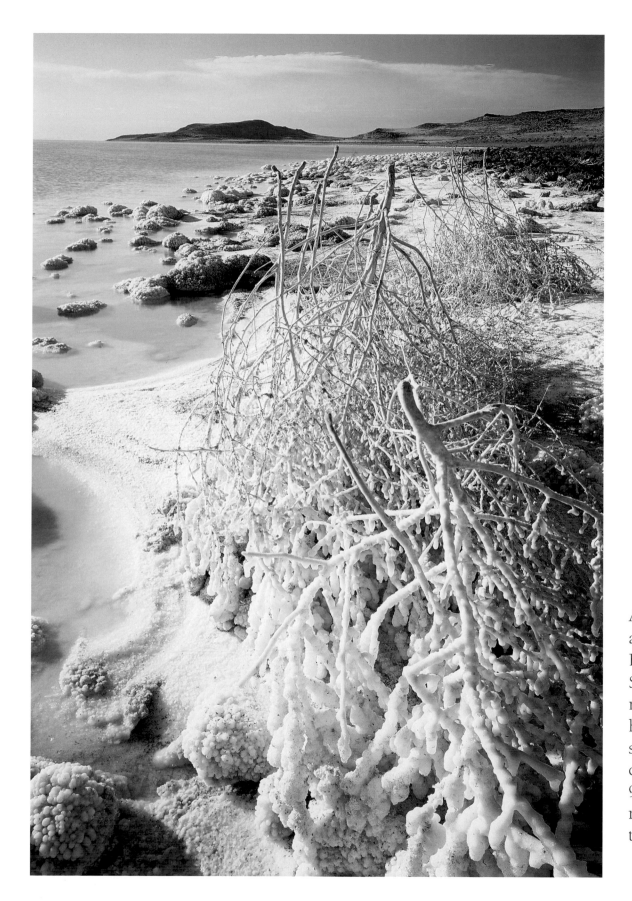

A remnant of ancient Lake Bonneville, Great Salt Lake contains so much salt because it has no outlet to the sea. The lake's salt content varies from 9 to 28 percent, making it saltier than the ocean.

13

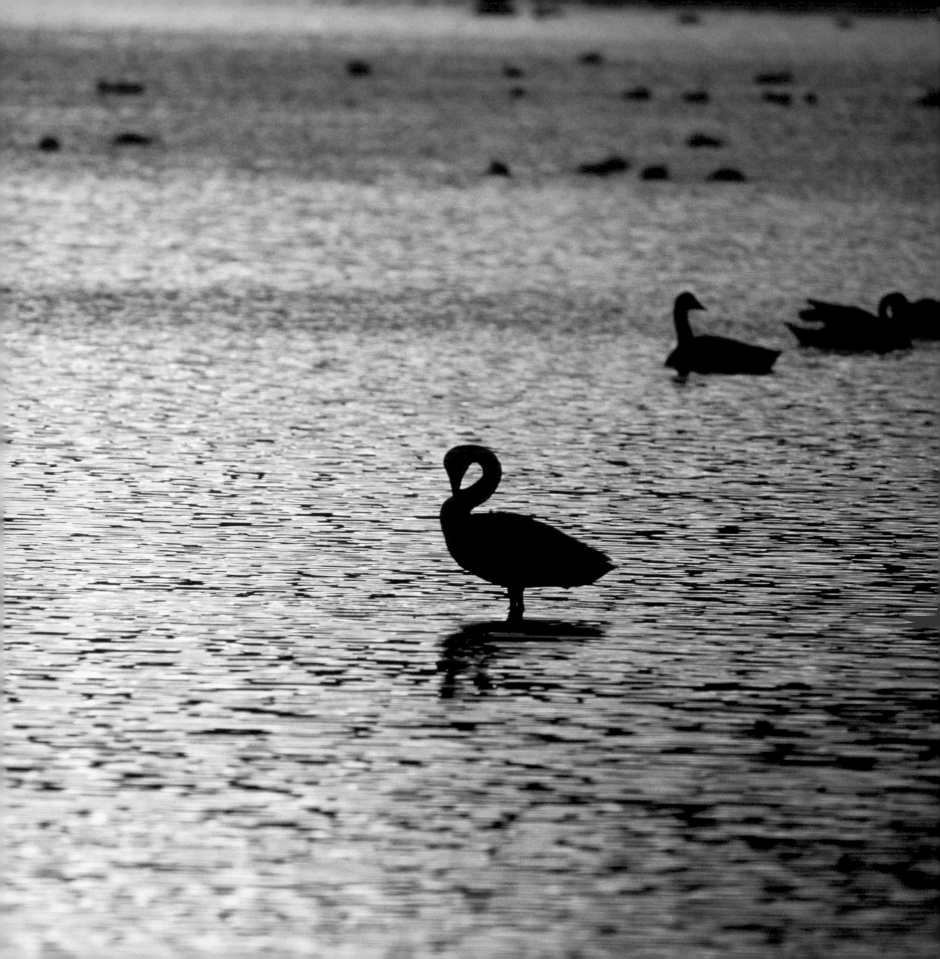

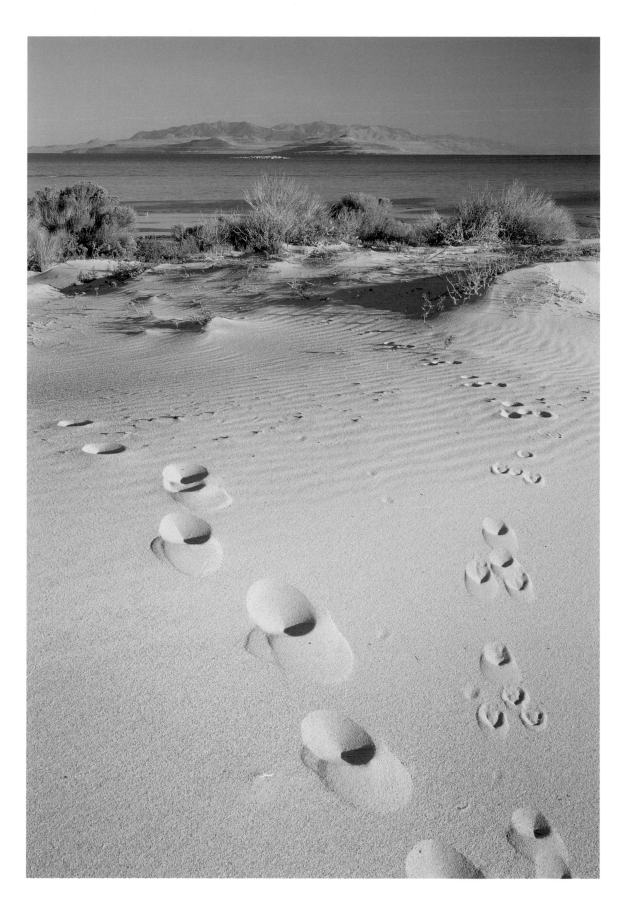

FACING PAGE
Located at the northern end of Great Salt Lake, the Bear River Migratory Bird Refuge has offered almost 75,000 acres of sanctuary to a variety of waterfowl and shorebirds for more than 75 years.

Popular with outdoor enthusiasts, Antelope Island offers more than 28,000 acres of pristine natural surroundings. The island is home to an array of wildlife, including a herd of more than 600 American Bison introduced to the island in 1893.

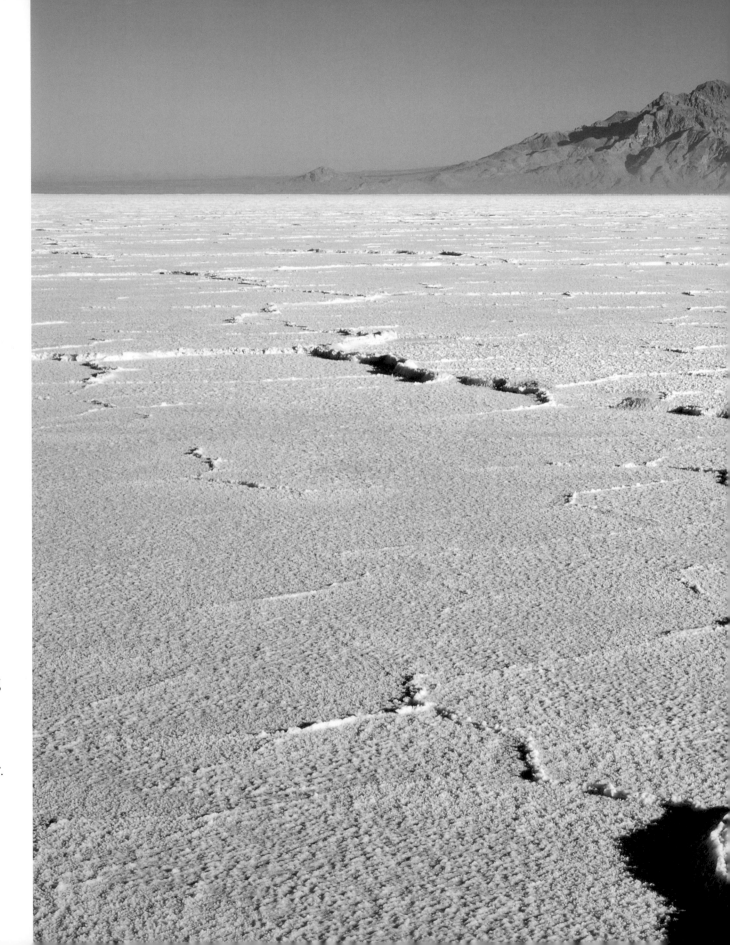

The sands of Great Salt Lake Desert are white from the salt deposited by the extinct Lake Bonneville. Covering 4,000 square miles, the desert stretches from Great Salt Lake to the Nevada border.

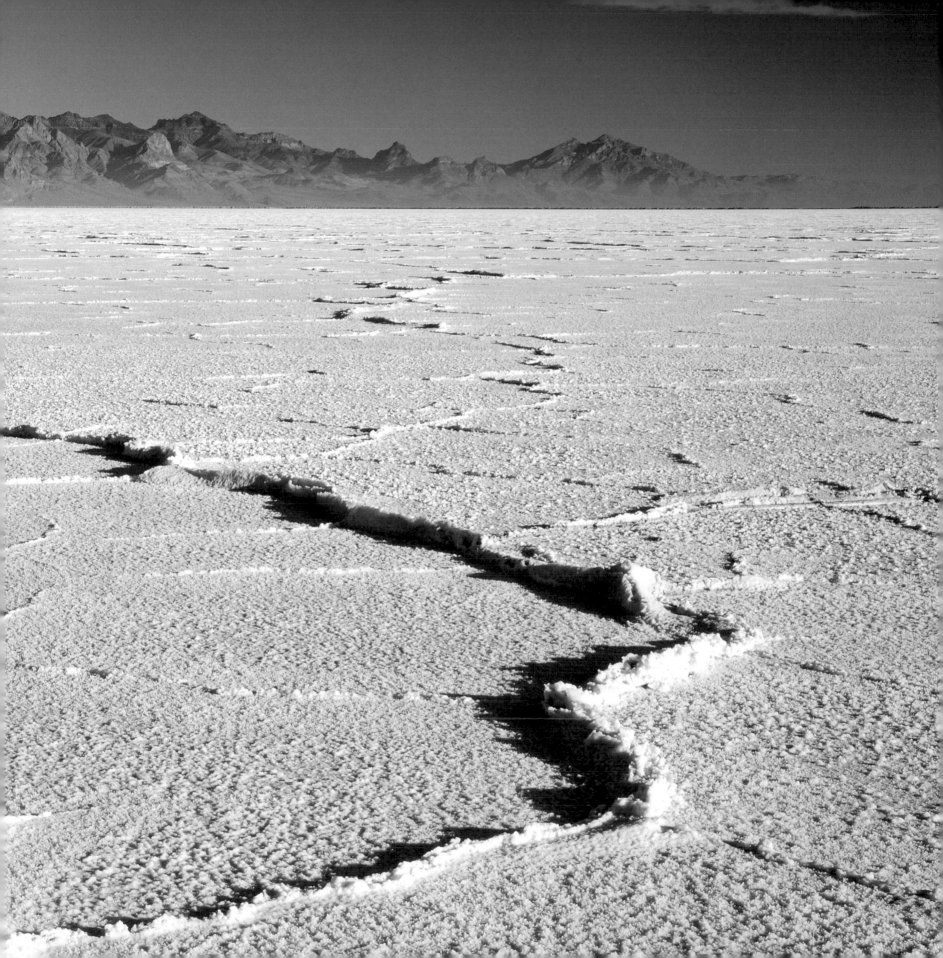

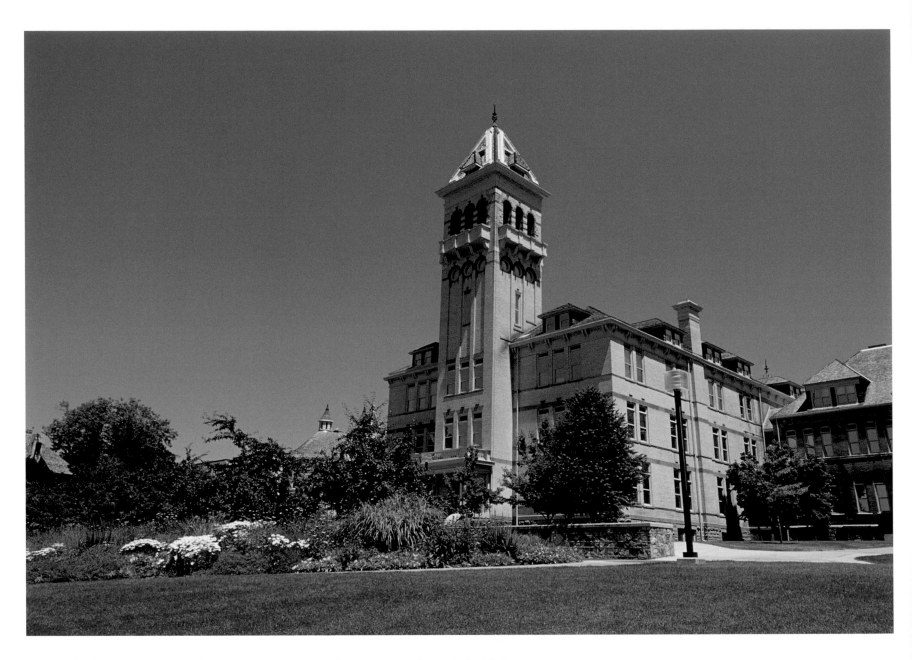

Founded in 1888, Utah State University has more than 23,000
undergraduate and graduate students and offers over 200 majors.

Each year, the city of Logan in north Utah hosts the Festival of the American West. Celebrating the music and theater of the Old West, the event features dancing, storytelling, and history presentations.

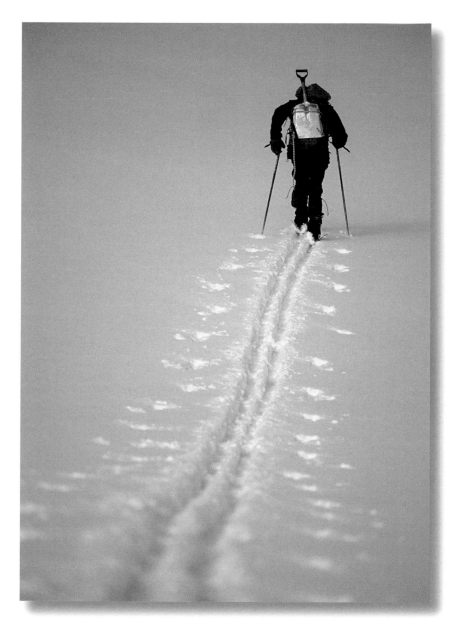

Visitors from all around the world take advantage of Utah's 13 ski resorts offering Olympic-class skiing. The state has a reputation for some of the best snow conditions in the world.

The snow in Utah is unusually dry, earning it a reputation as the "Greatest Snow on Earth."

The brilliant turquoise color of Bear Lake results from limestone particles suspended in the water. Boaters, swimmers, and fishermen all take advantage of the 20-mile-long lake.

Situated in the Wasatch-Cache National Forest, the Jardine Juniper is said to be more than 3,000 years old. A hike to this ancient tree includes breathtaking views of the Bear River Mountain Range.

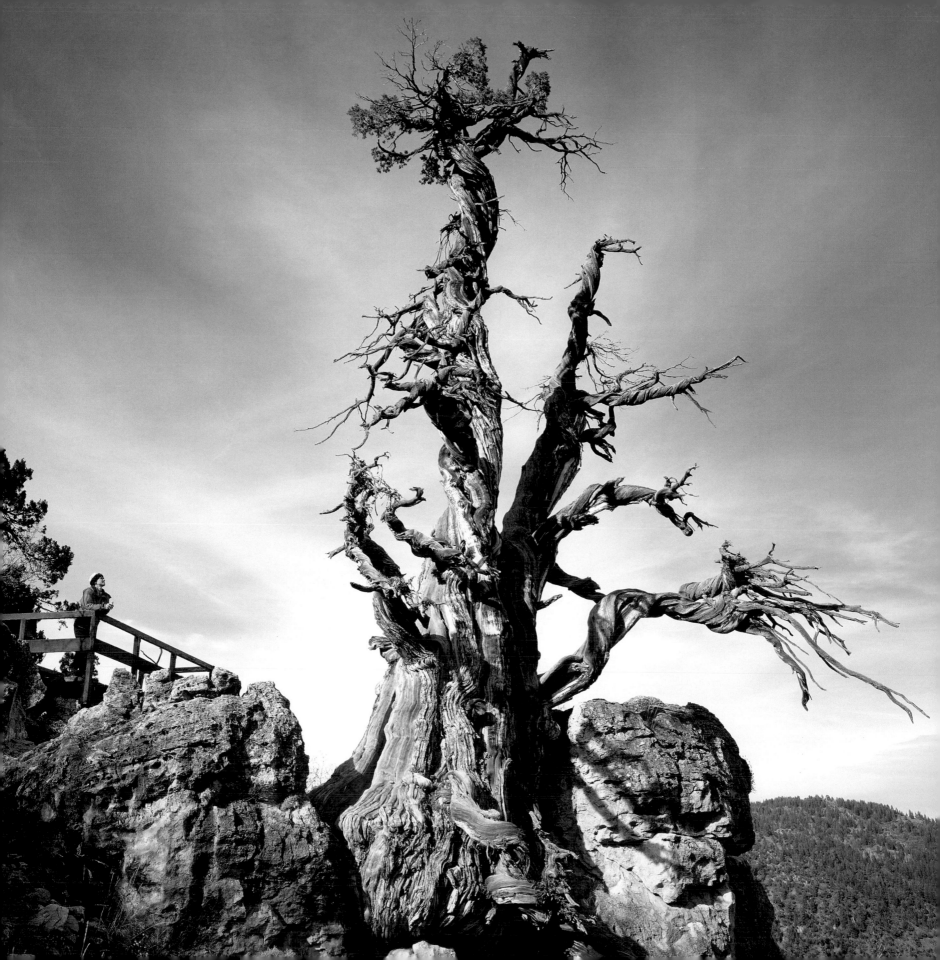

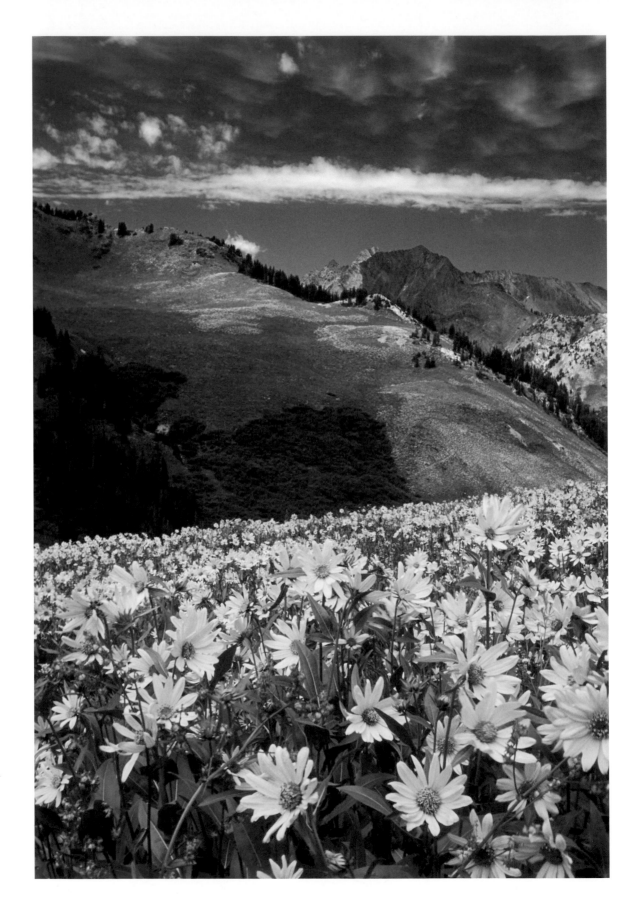

The Wasatch-Cache National Forest occupies almost 1.3 million acres. Popular with skiers, hikers, and campers, this diverse forest contains seven wilderness areas and is one of the most visited forests in the country.

Home to almost 8,000 people, Park City hosts the Sundance Film Festival and boasts three major ski resorts: Park City, Deer Valley, and The Canyons.

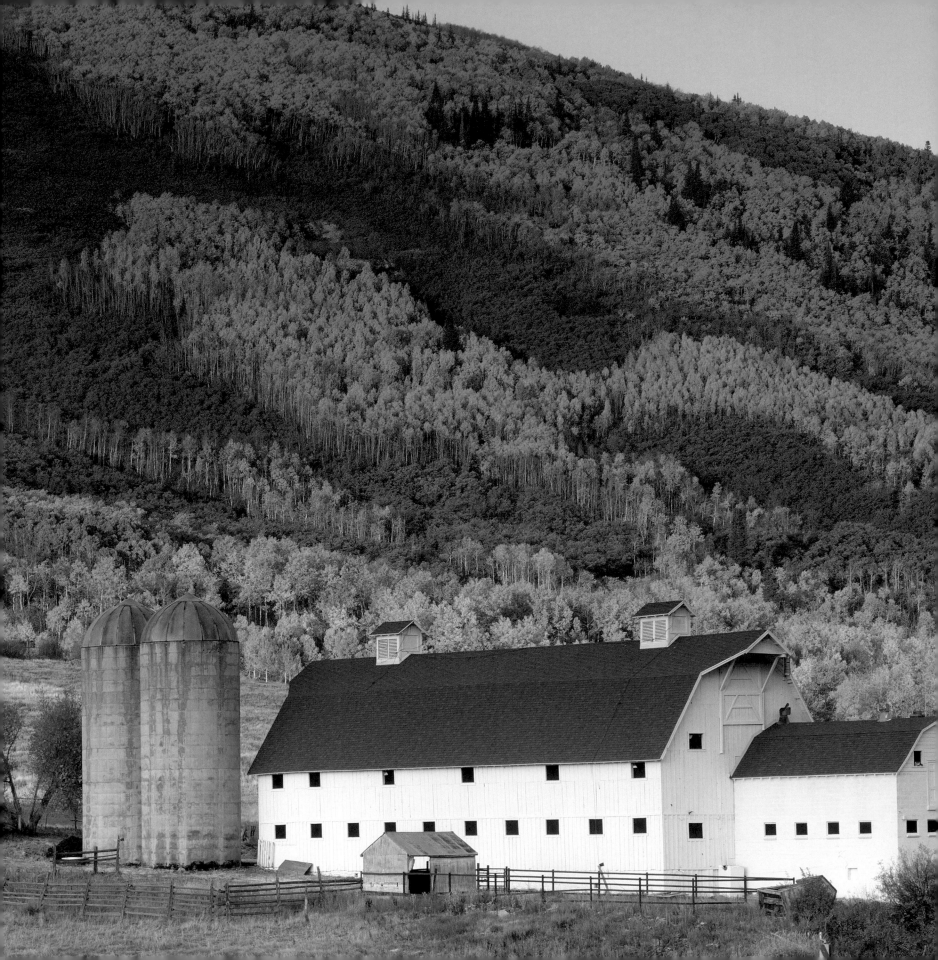

The stretch of highway between Brigham and Willard is called the Fruitway. During the growing season, this highway is lined with roadside stands selling fresh produce.

Utah's largest agricultural commodities include cattle, dairy, hay, and hogs.

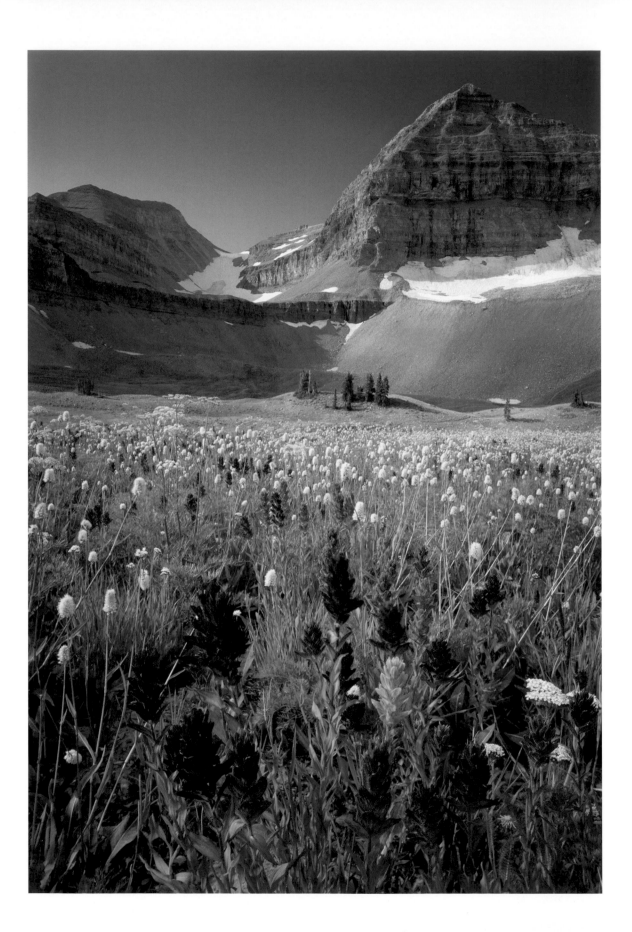

The strenuous climb to the peak of the second highest summit in the Wasatch-Cache Range—Mount Timpanogos—is a popular annual activity.

The beehive became the official state emblem of Utah—nicknamed the "Beehive State"—in 1959. The beehive symbolizes industry and the pioneer values of thrift and perseverance.

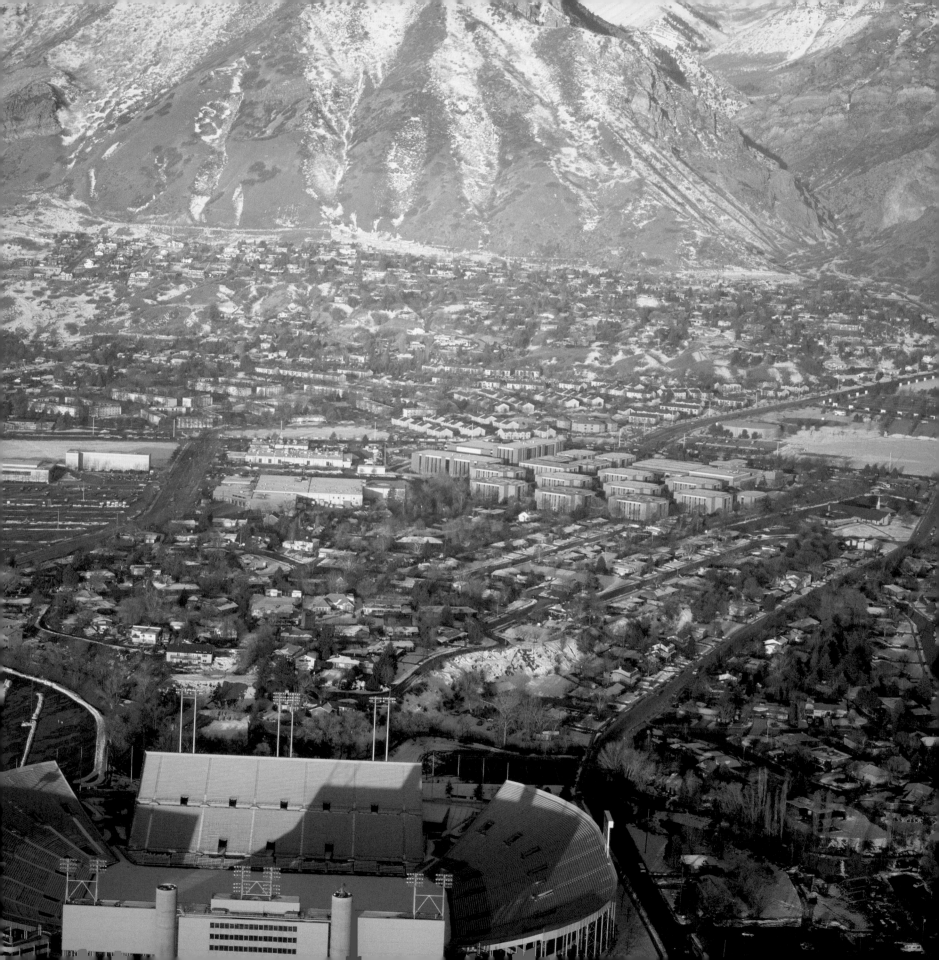

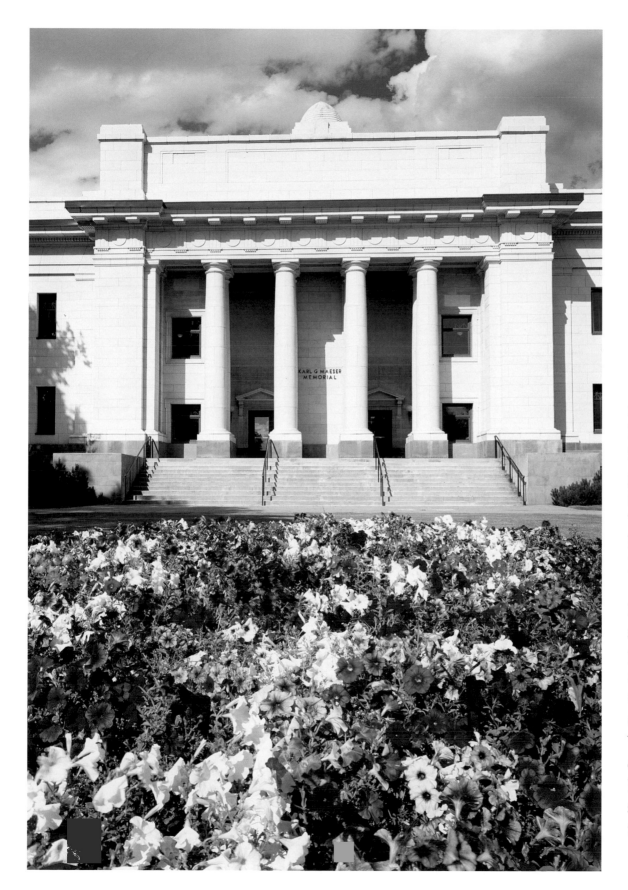

FACING PAGE
Provo was settled in 1849 by a small group of Mormons from Salt Lake City. The city is now home to more than 100,000 residents.

Named after the second prophet and president of The Church of Jesus Christ of Latter-day Saints, Brigham Young University was established in 1875. More than 25,000 students now attend the university.

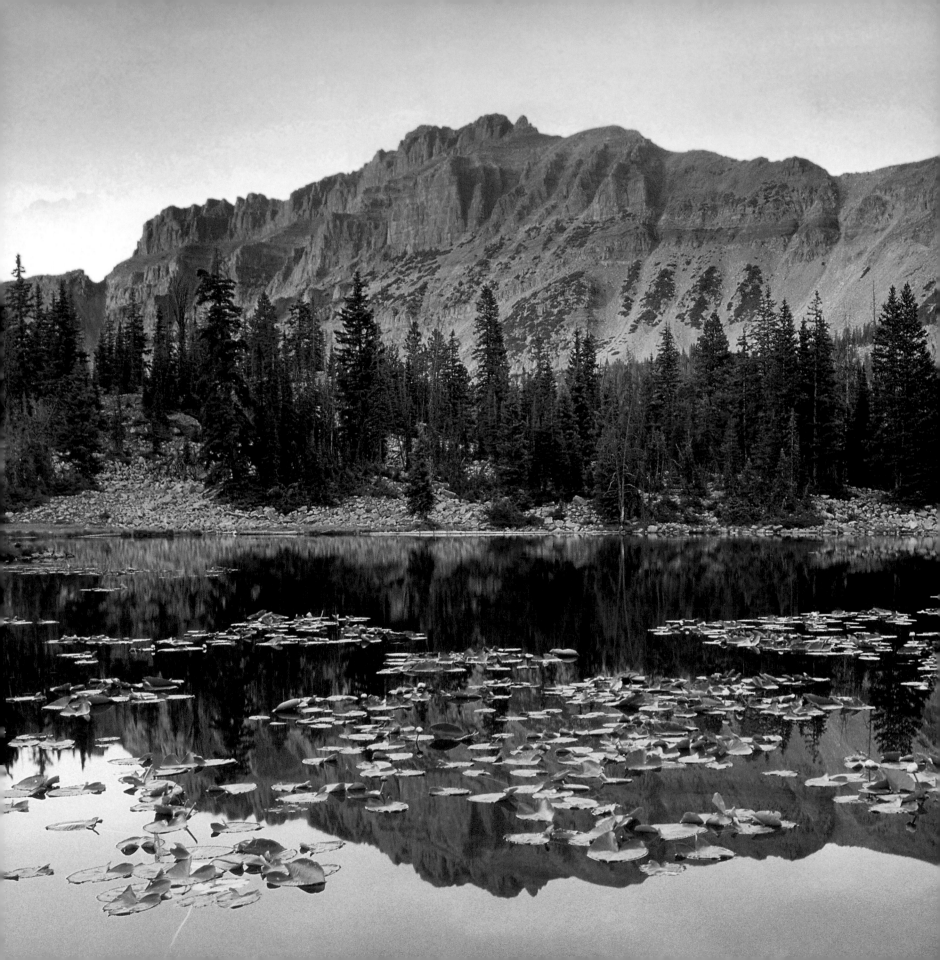

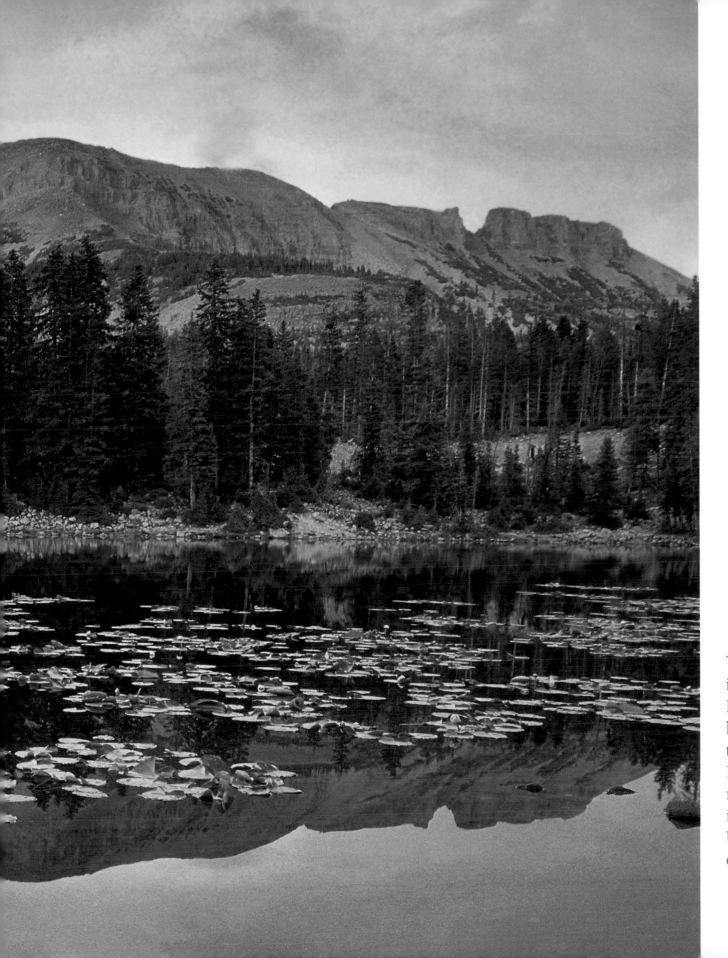

The highest range in Utah—the Uinta Range—reaches heights of more than 13,500 feet. It's the only major mountain range in the continental United States to run east west.

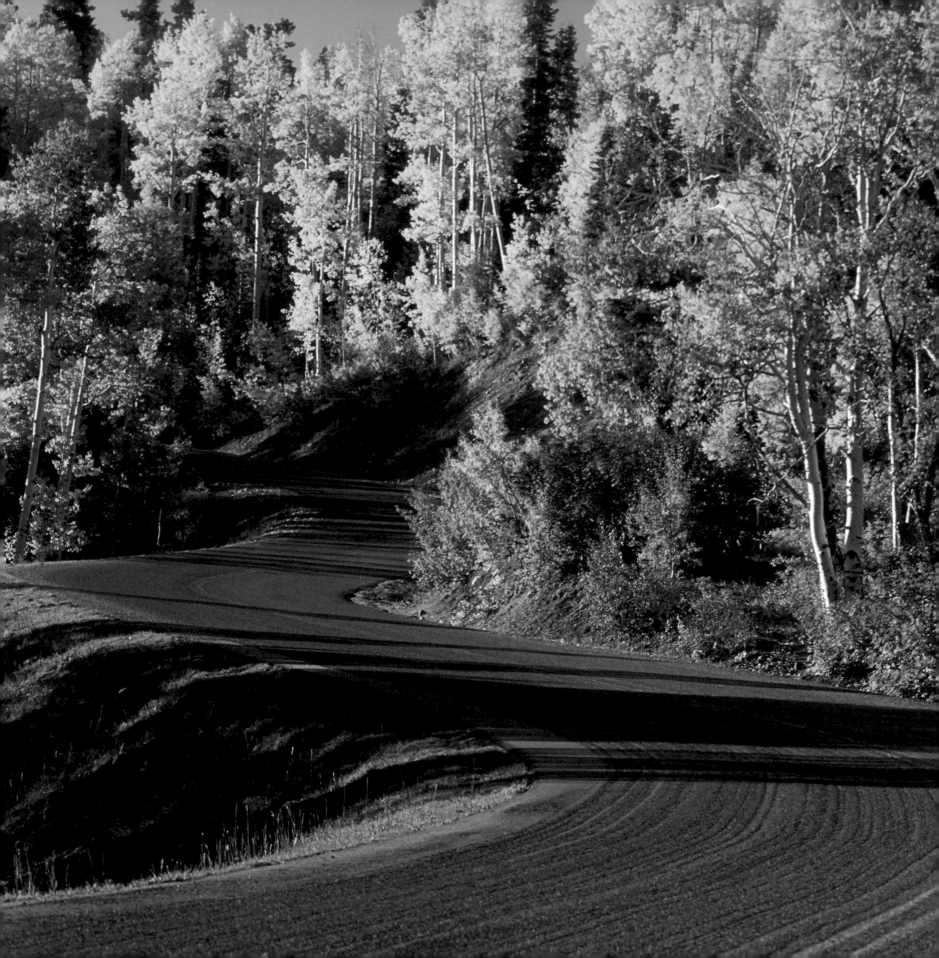

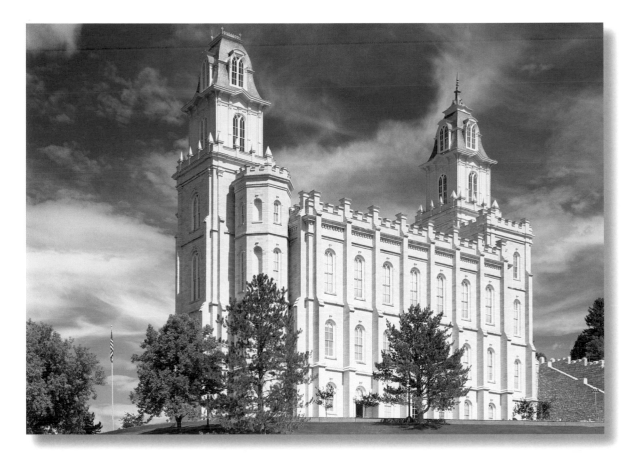

Built in 1888, the Manti Temple hosts the Mormon Miracle Pageant. Each June, the temple grounds become a giant stage for a dramatic presentation of Jesus Christ's visit to the American continents.

Nebo Loop winds through Uinta National Forest between the towns of Nephi and Payson. Offering stunning views of the Wasatch Mountains and brilliant fall foliage, this scenic byway climbs over 9,000 feet in elevation.

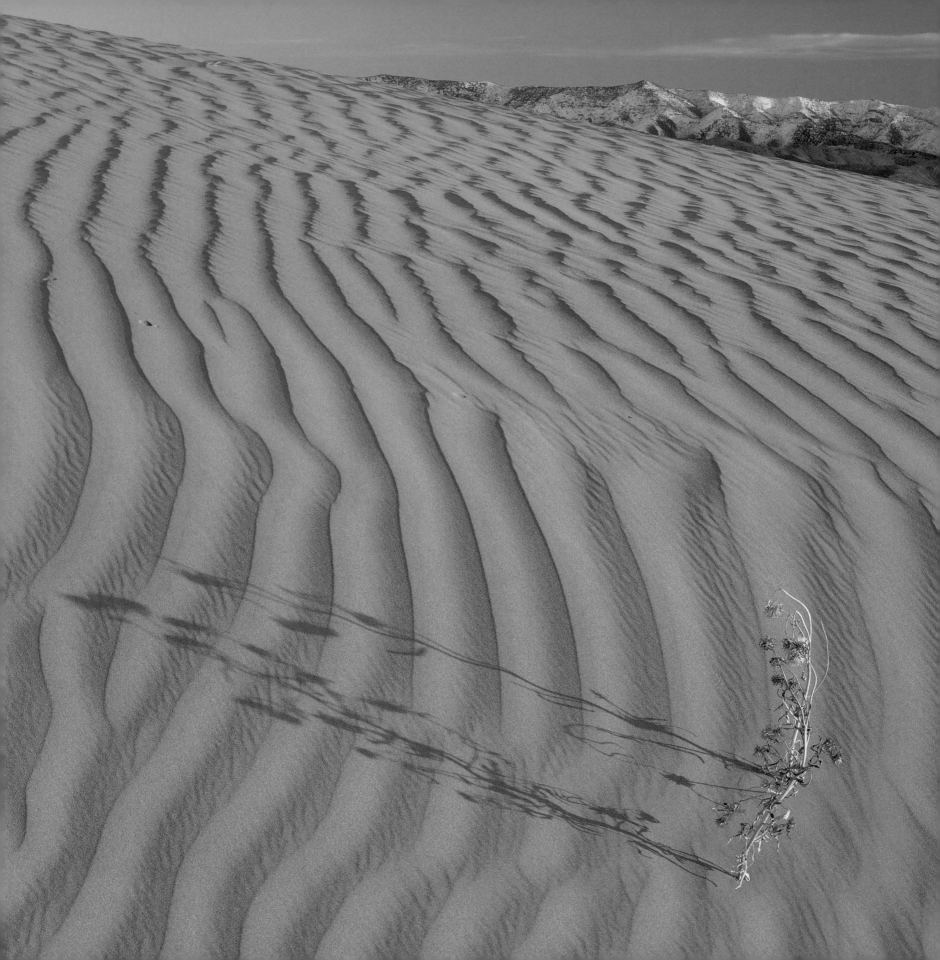

FACING PAGE
The Little Sahara
Recreation Area
is one of the larg-
est dune fields in
Utah. The remnants
of an ancient river
that once flowed
into Lake Bonneville
15,000 years ago, the
dunes slowly shift to
the north and east
between five and
nine feet per year.

A memorial stands as
a tribute to lives lost
at war in the small
community of Vernal.

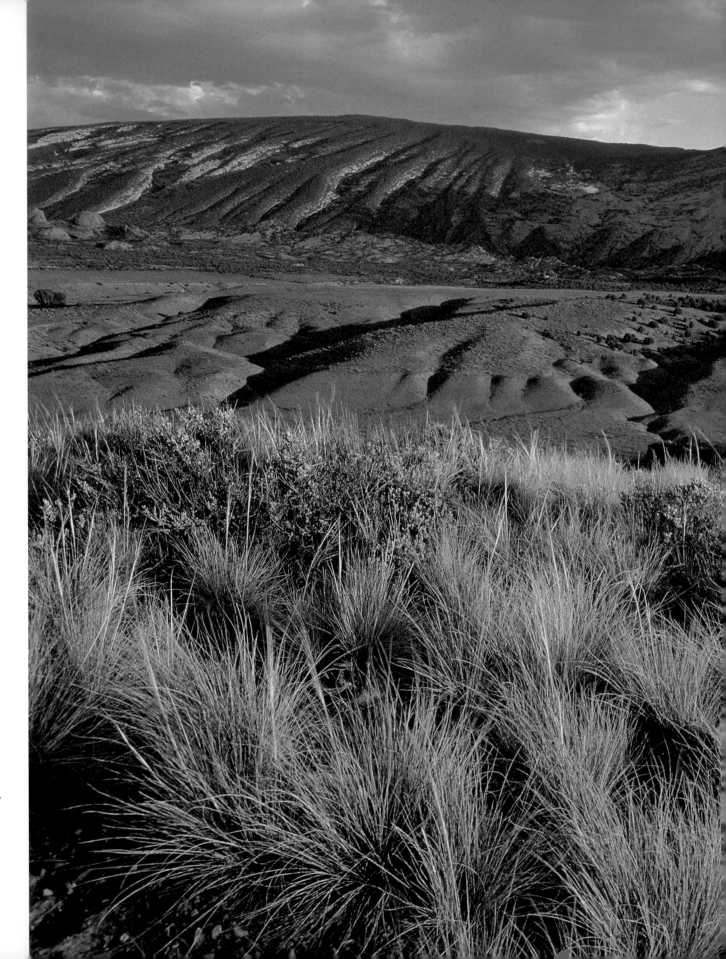

The rugged peaks of Split Mountain rise above Dinosaur National Park. Visitors can take in this breathtaking landscape while enjoying the park's camping facilities.

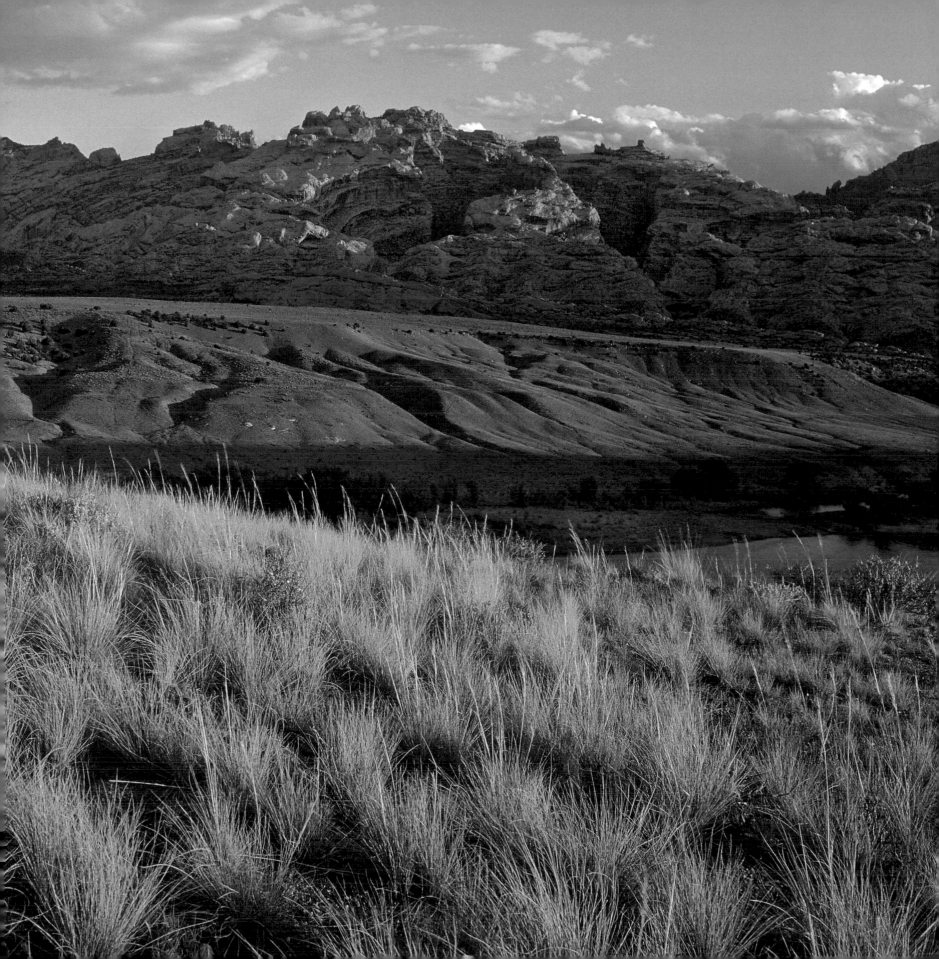

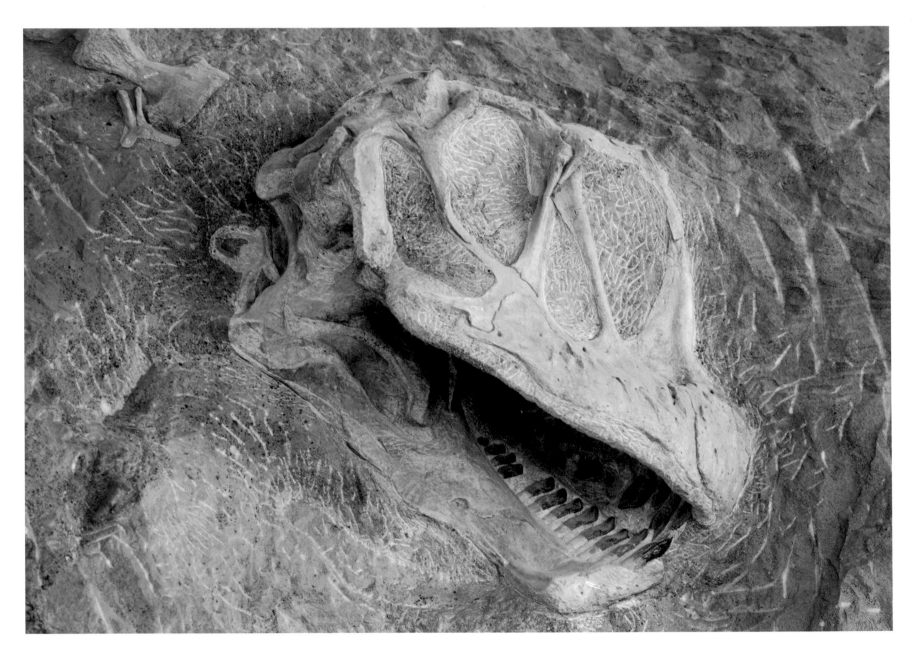

Named for the 350 tons of fossils discovered in the area, Dinosaur National Park contains the largest concentration of Jurassic period dinosaur bones ever found. Visitors can see more than 2,000 bones exposed in an open rock face at the Quarry Visitor Center.

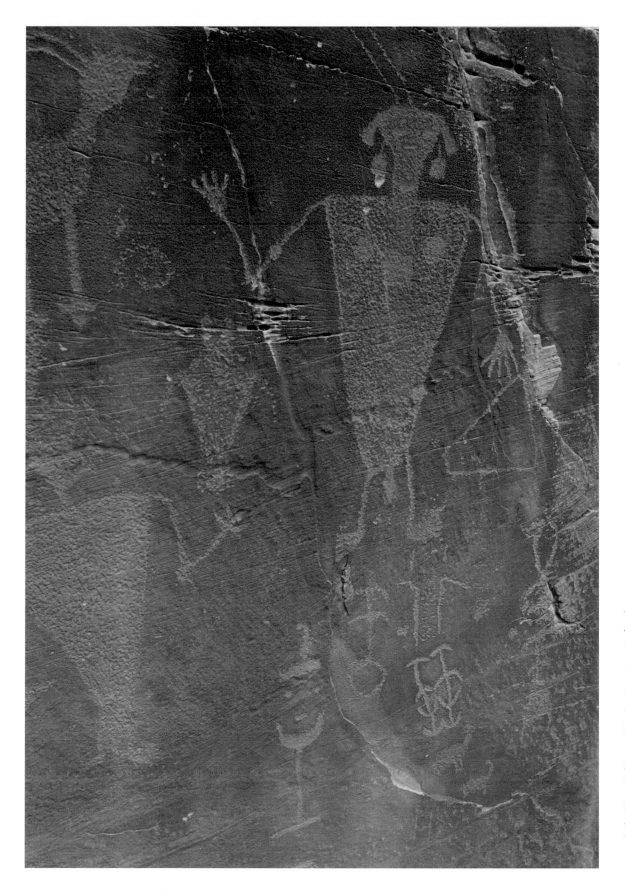

Ancient societies —such as that of the Fremont people—left their mark on the red stone cliffs of Dinosaur National Park. These petroglyphs, found throughout the state, are more than 1,000 years old.

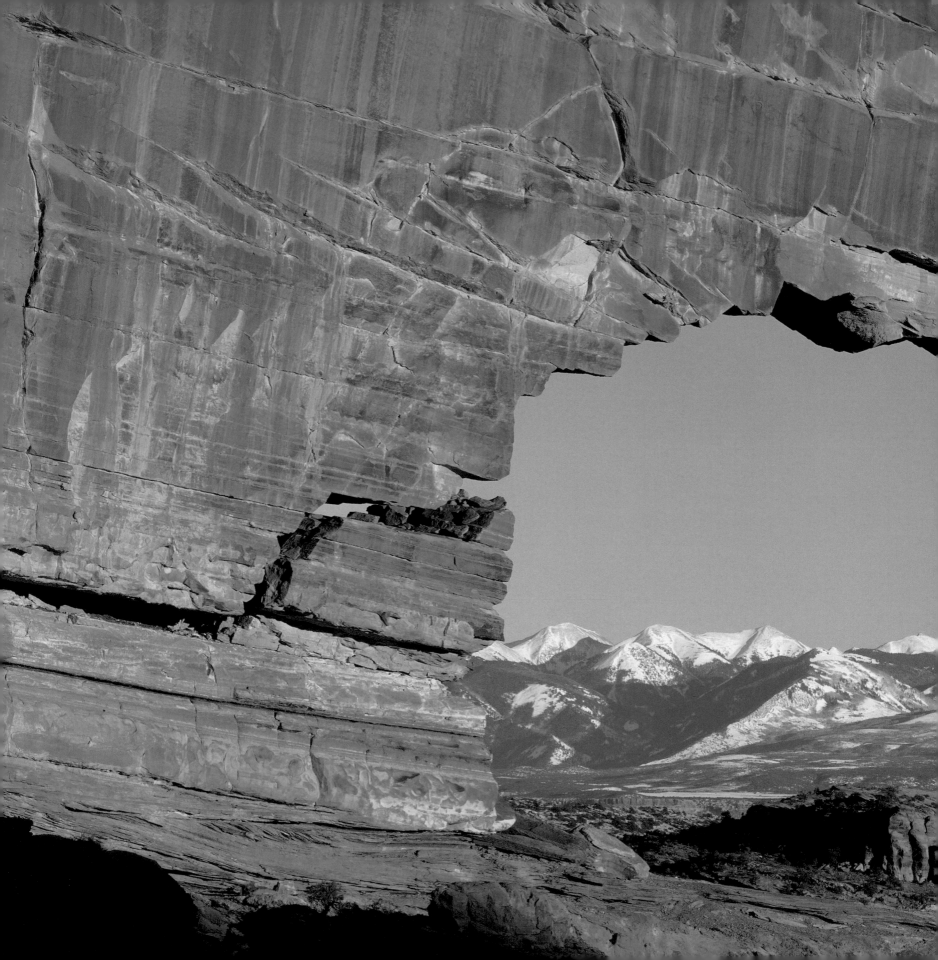

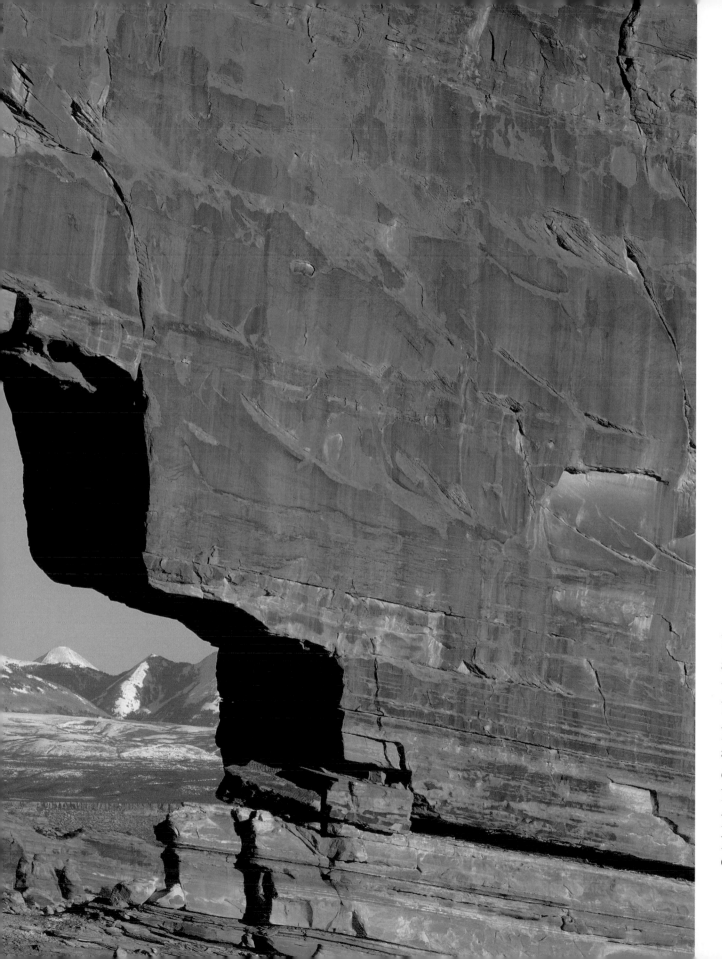

Named for the Jeep-shaped "window" in the rock face, Jeep Rock is part of a proposed 51,100-acre wilderness area, called Behind the Rocks, that would preserve the region's pristine natural environment.

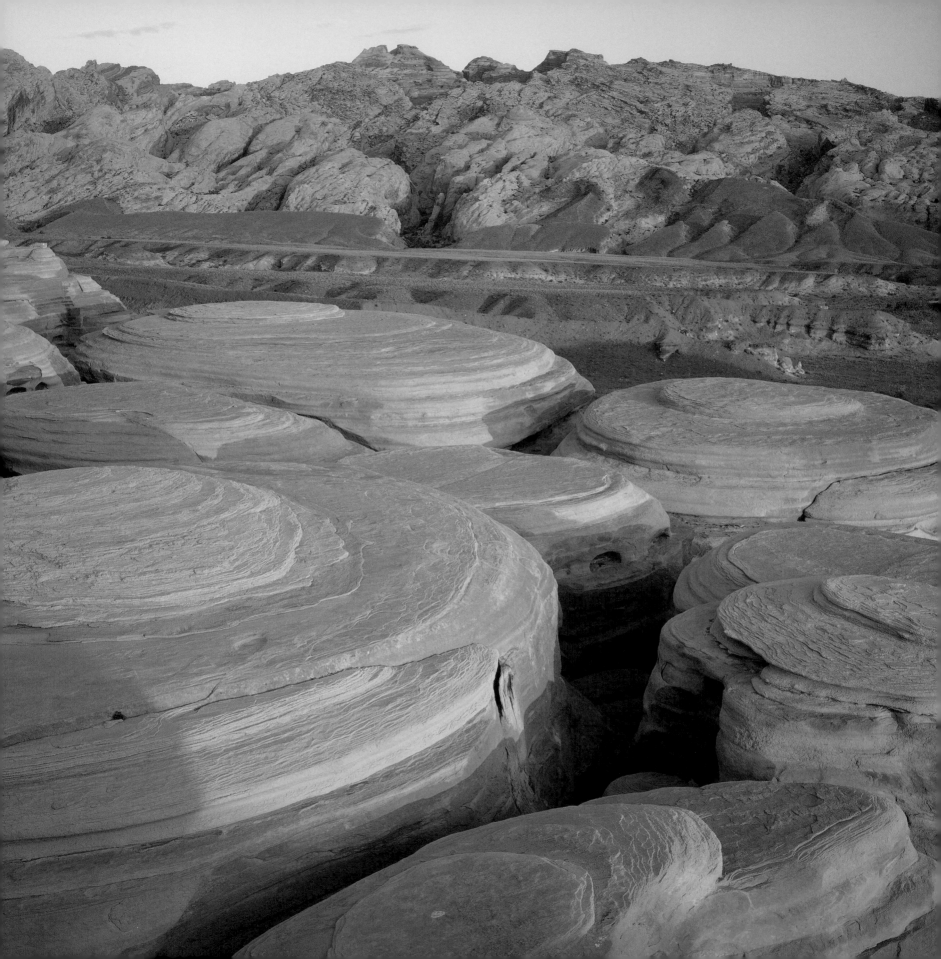

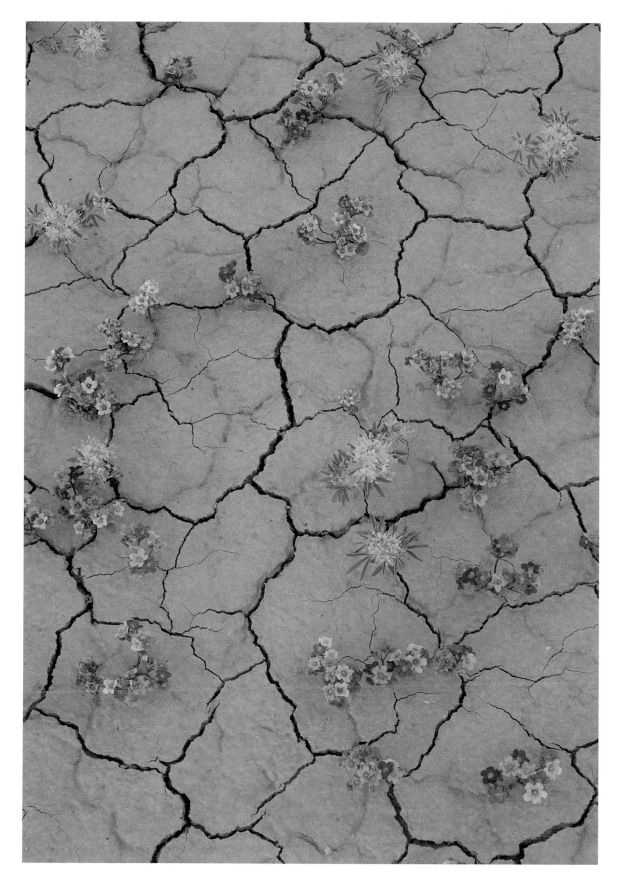

The San Rafael Swell is one of Utah's best-kept secrets. Few people visit the dramatic multi-hued rock formations, making it the ideal location for a solitary hike or undisturbed camping trip.

Desert wildflowers bloom throughout the spring and summer, covering the sandy terrain in an array of brilliant color.

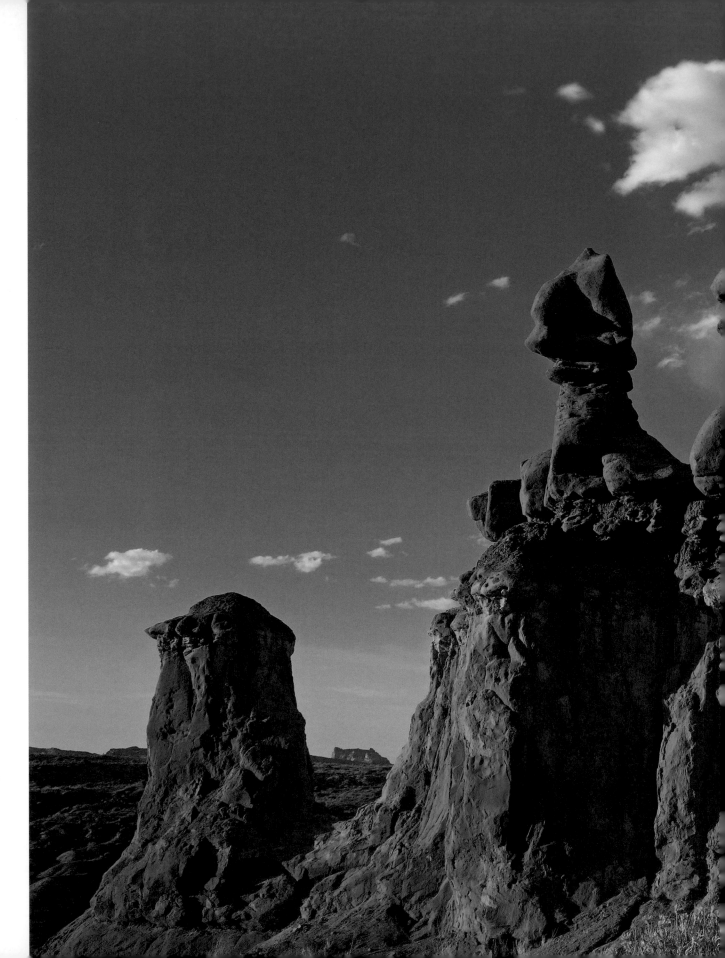

Goblin Valley State Park's odd geological formations give the park an extraterrestrial atmosphere. The film *Galaxy Quest* was shot in this otherworldly landscape.

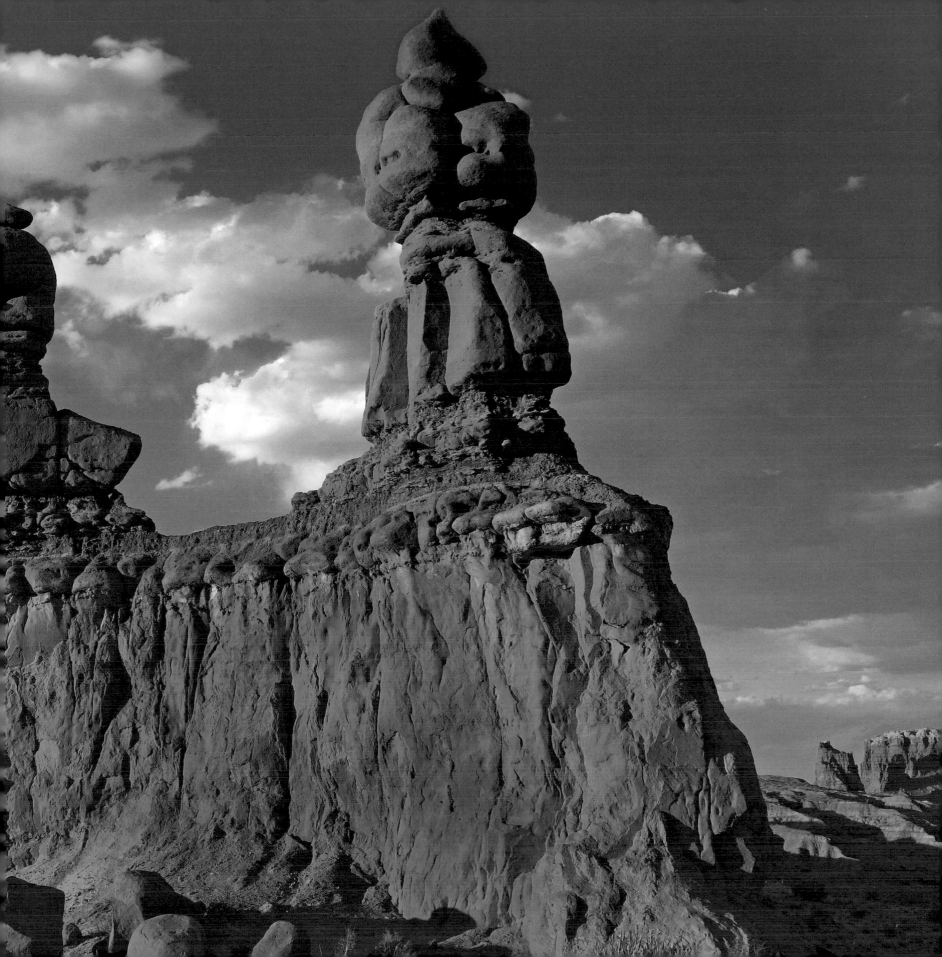

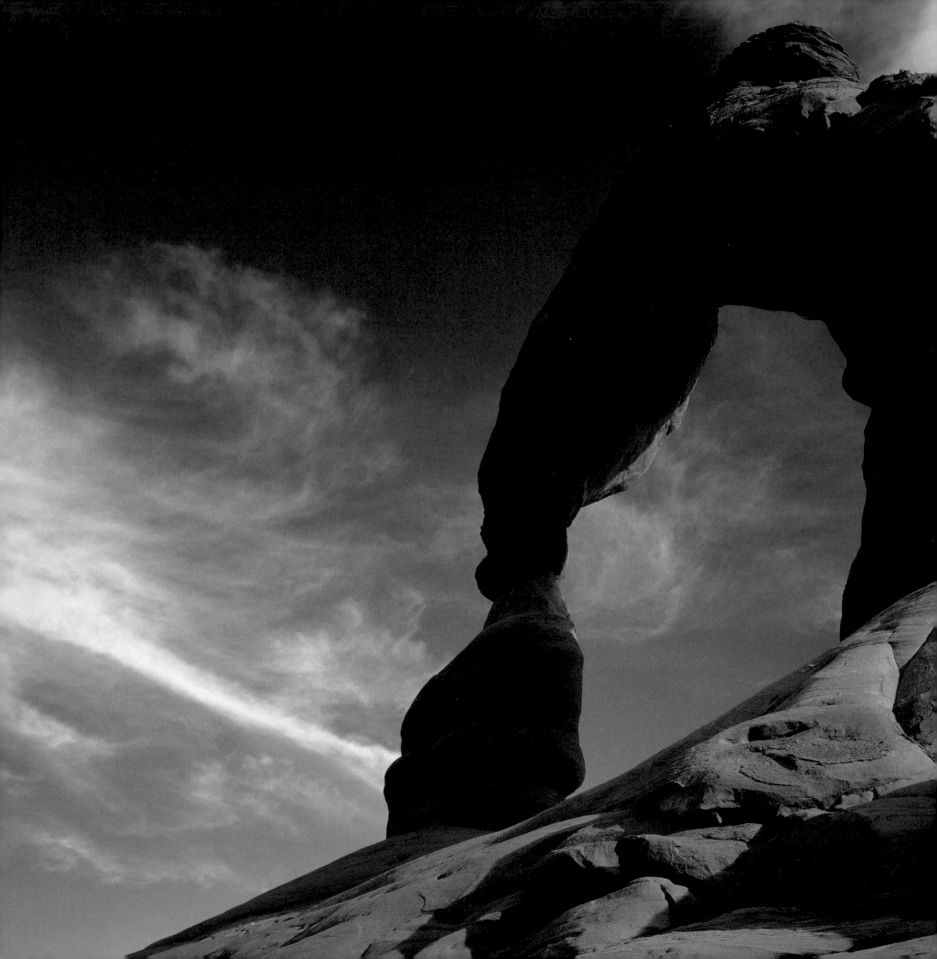

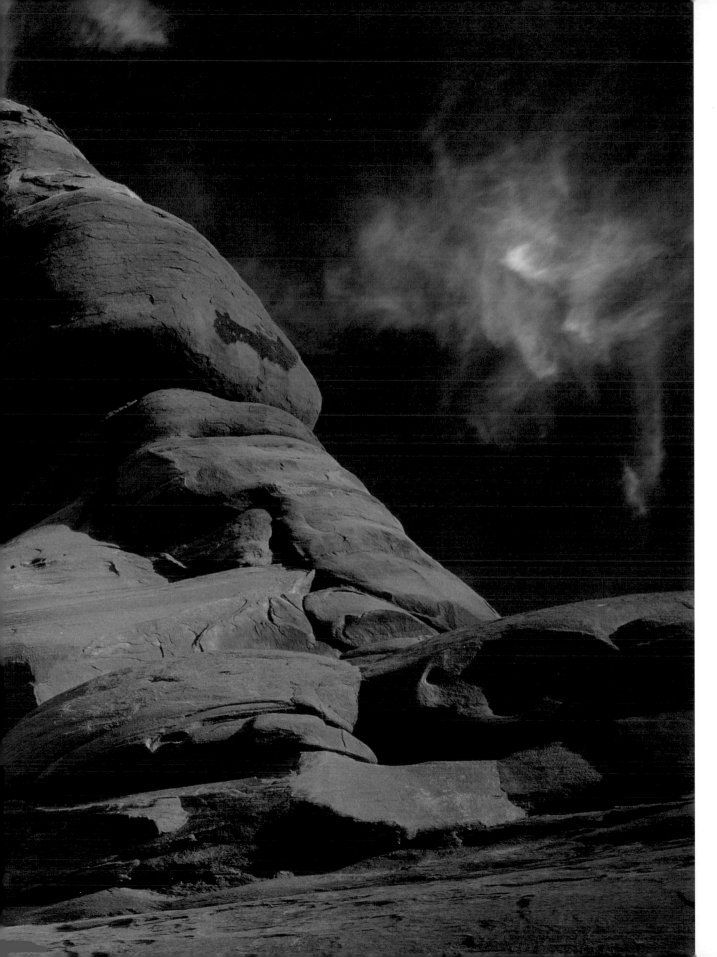

Located in Arches National Park, Utah's most famous icon—Delicate Arch—is one of the state's most photographed destinations.

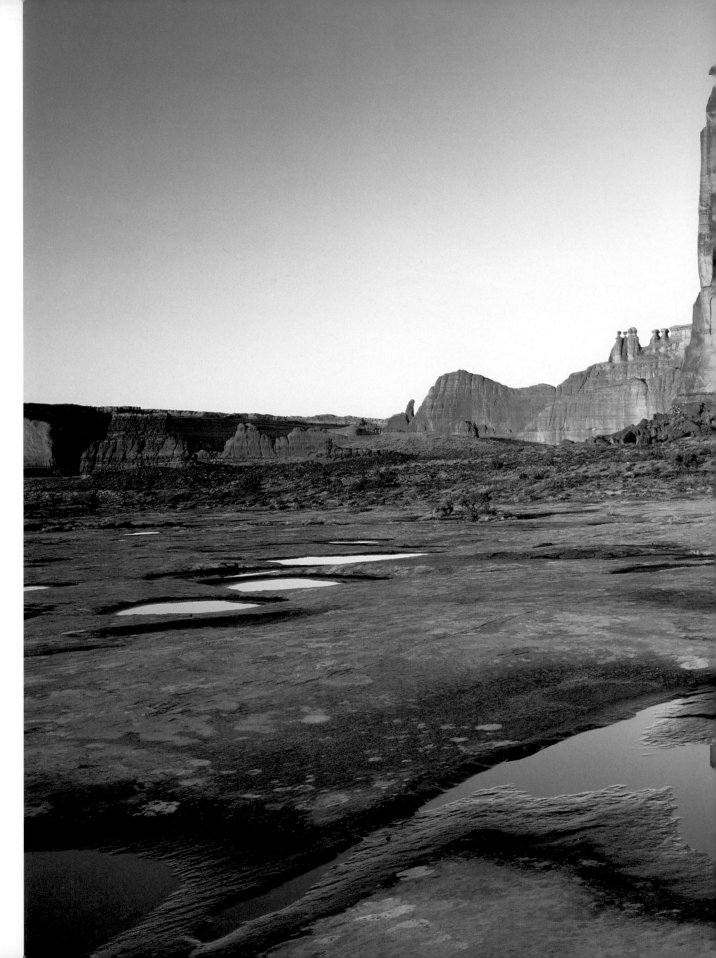

Bizarre rock formations—pinnacles, spires, fins, and arches—populate the striking red desert of the 73,000-acre Arches National Park.

OVERLEAF
Arches National Park contains more than 2,000 sandstone arches. Visitors can drive through the park on a 40-mile stretch of paved road to visit the startling multi-hued rock formations.

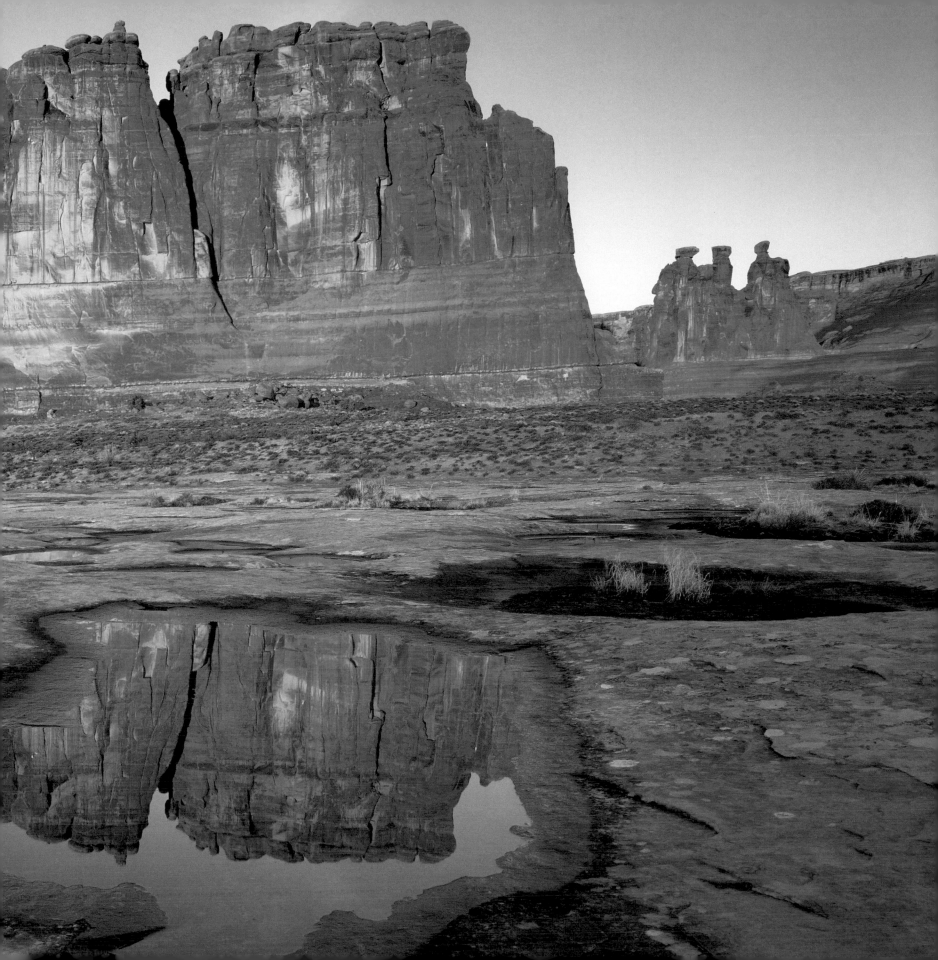

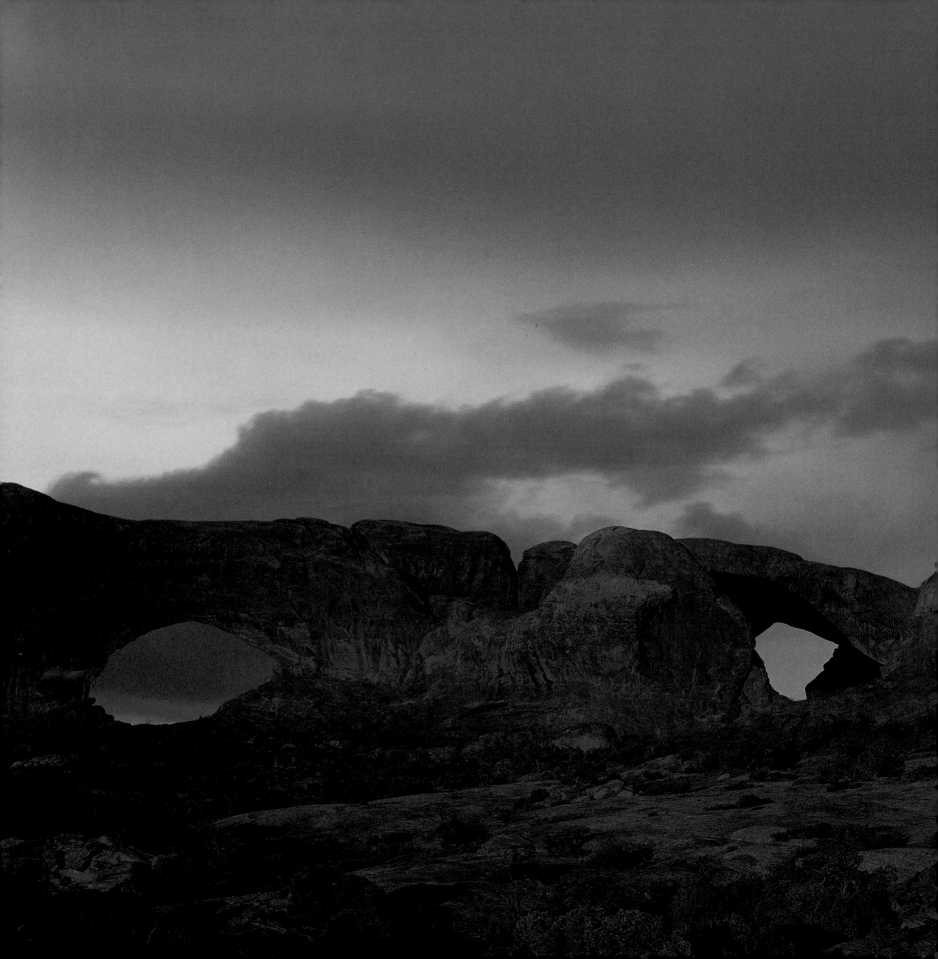

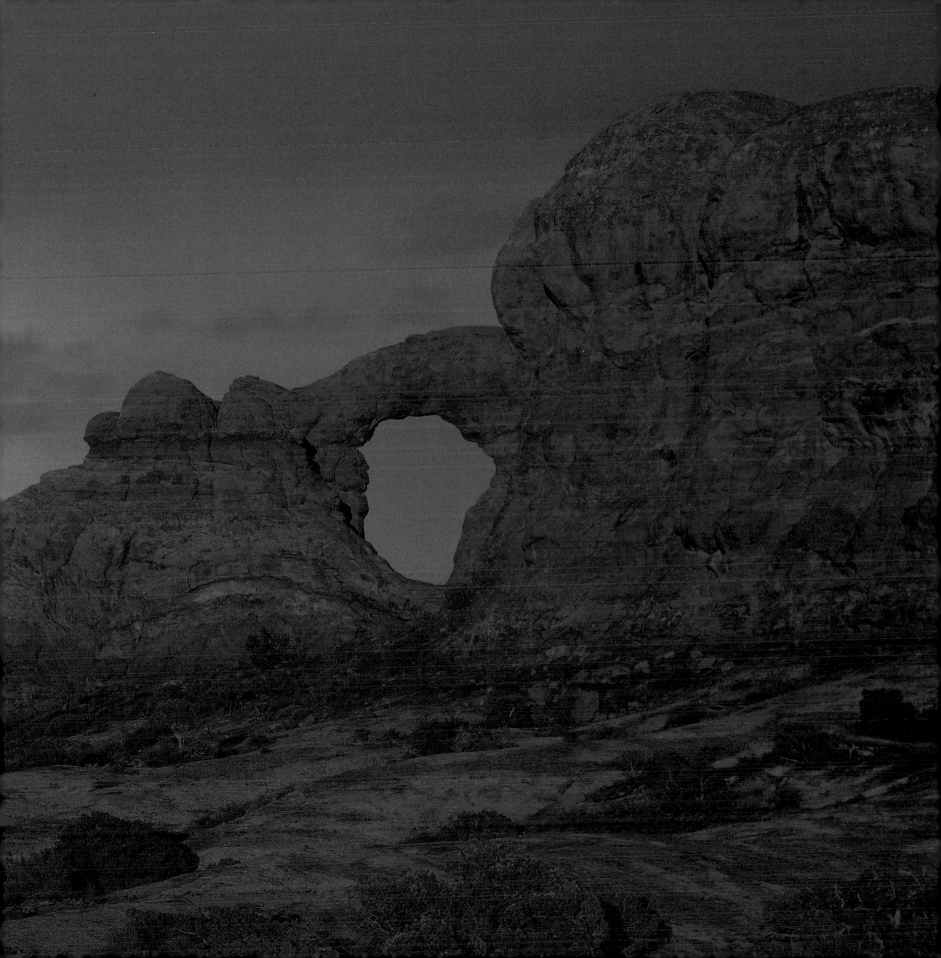

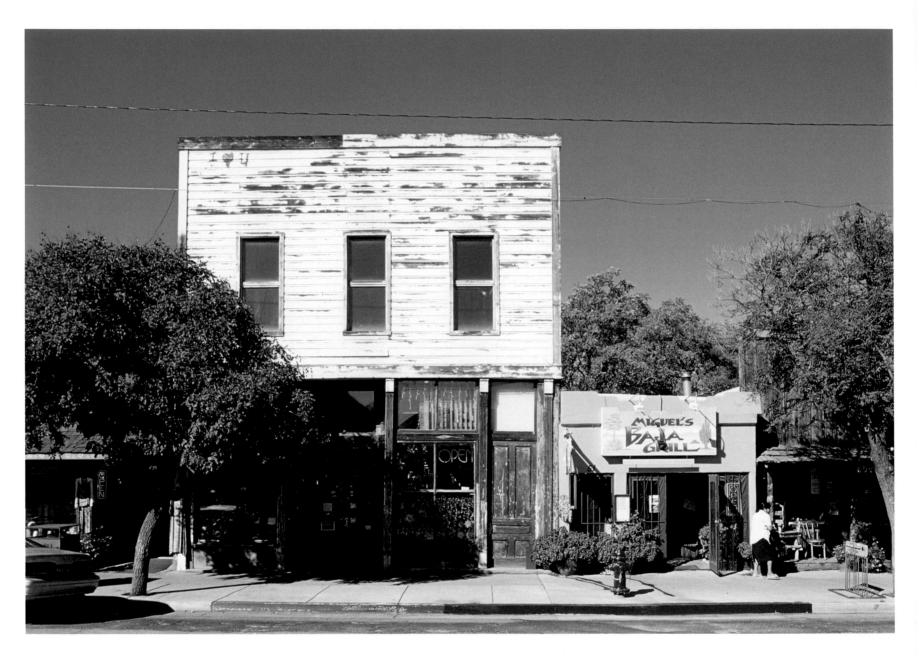

An outdoor enthusiast's paradise, the town of Moab provides access
to Arches National Park, Canyonlands National Park, and Dead
Horse Point State Park. With its stunning natural surroundings,
the town offers hiking, mountain biking, and kayaking.

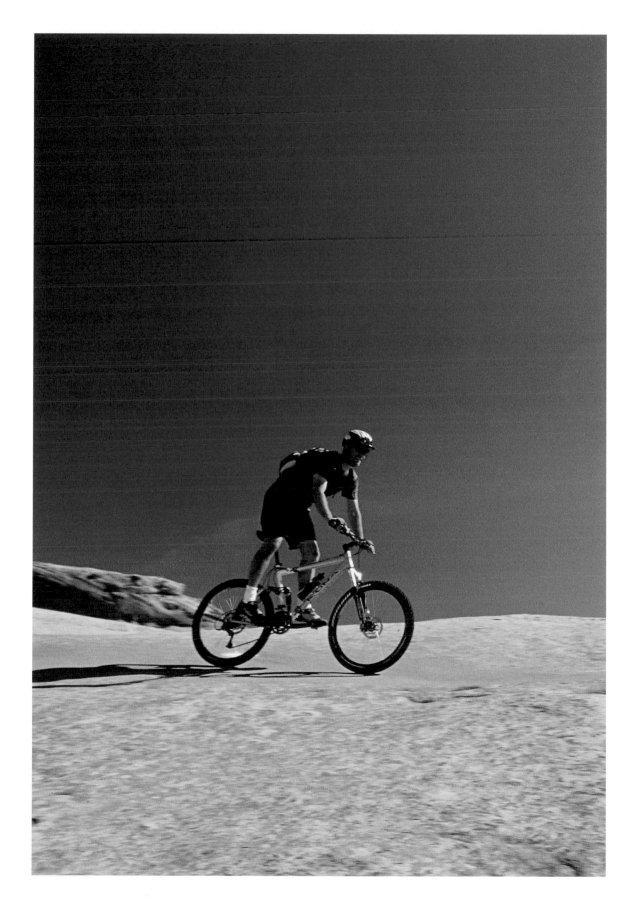

With trails for bikers of all levels, Moab claims to offer the best mountain biking on earth. The most famous is the challenging 9.6-mile Slickrock Bike Trail.

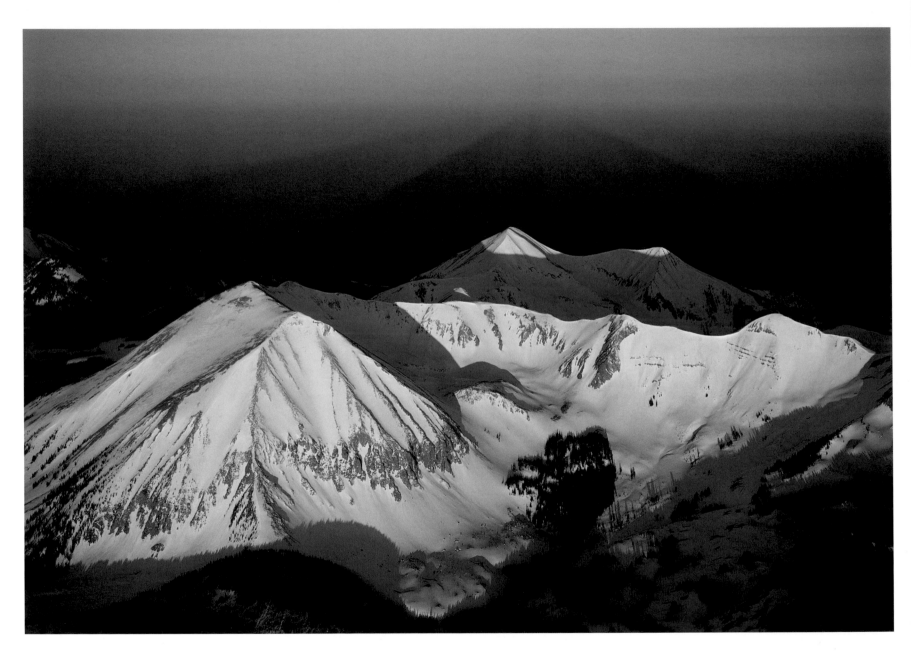

Set in the Manti-La Sal National Forest, the La Sal Mountains—
Utah's second highest range—have more than six snow-capped
peaks that reach over 12,000 feet.

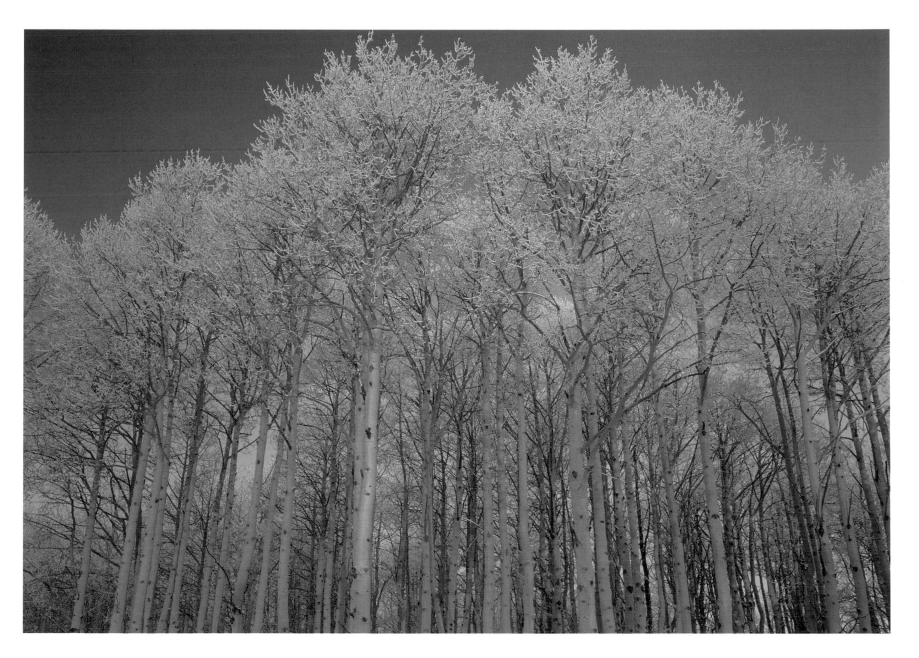

The Manti-La Sal National Forest contains almost 1.5 million acres of woodland. Ideal for camping and hiking, the forest combines wildlife preservation with forestry and mining.

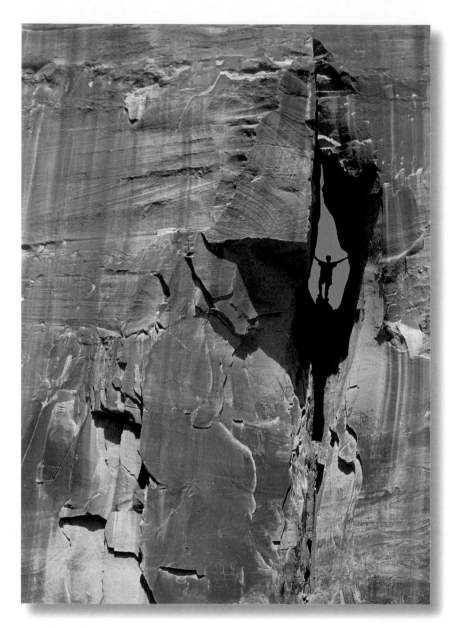

The Green and Colorado rivers wind through Canyonlands National Park, dividing it into four regions. Filled with endless desert, canyons, mesas, and buttes, the park covers more than 330,000 acres.

The park's altitudes range from 7,120 to 3,700 feet above sea level.

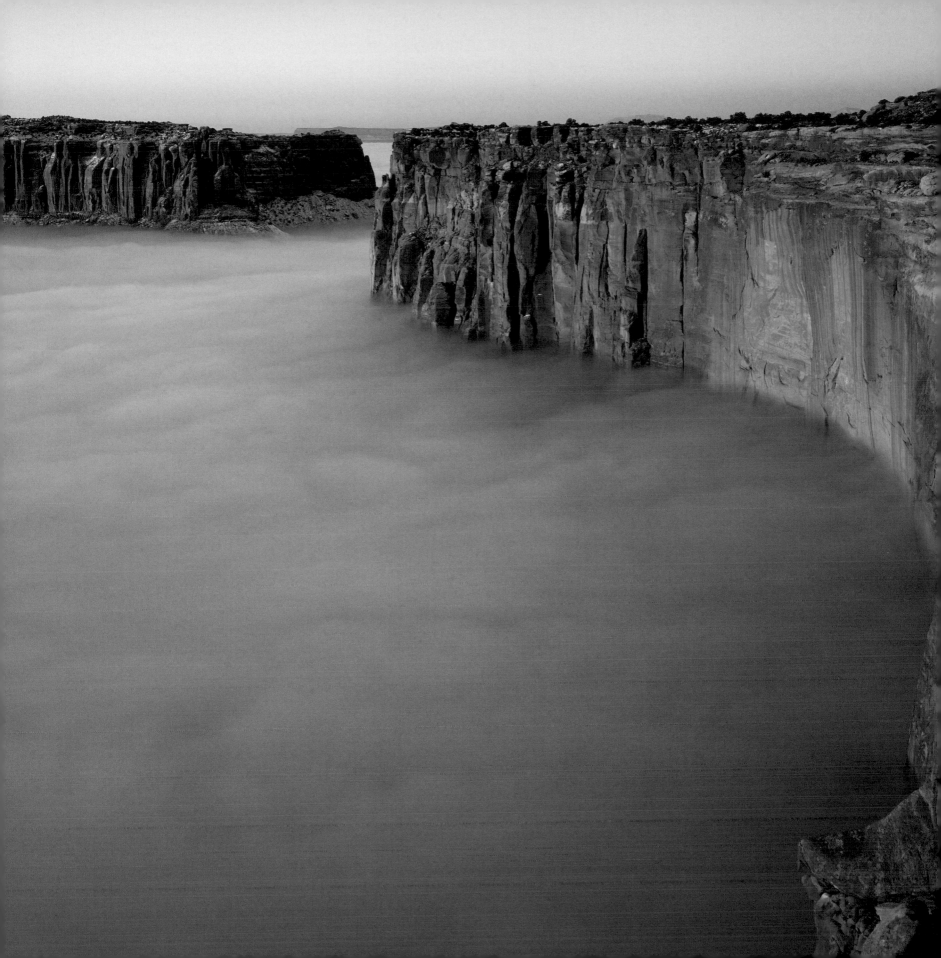

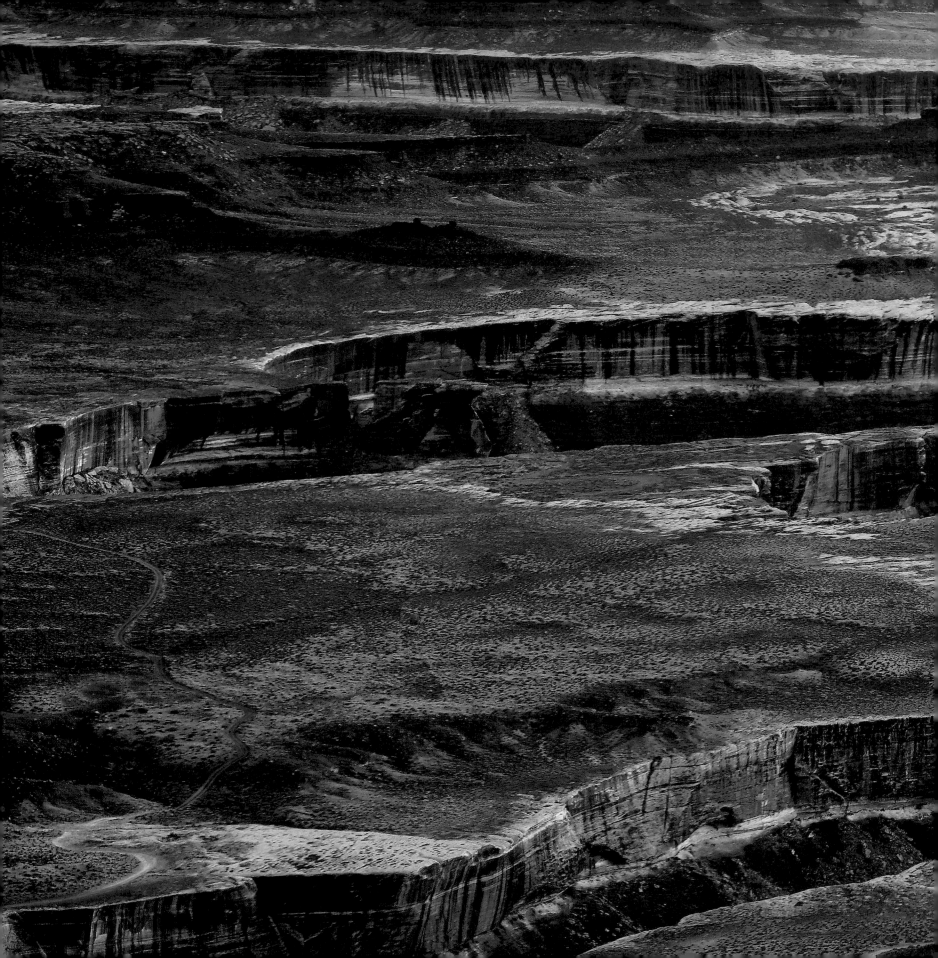

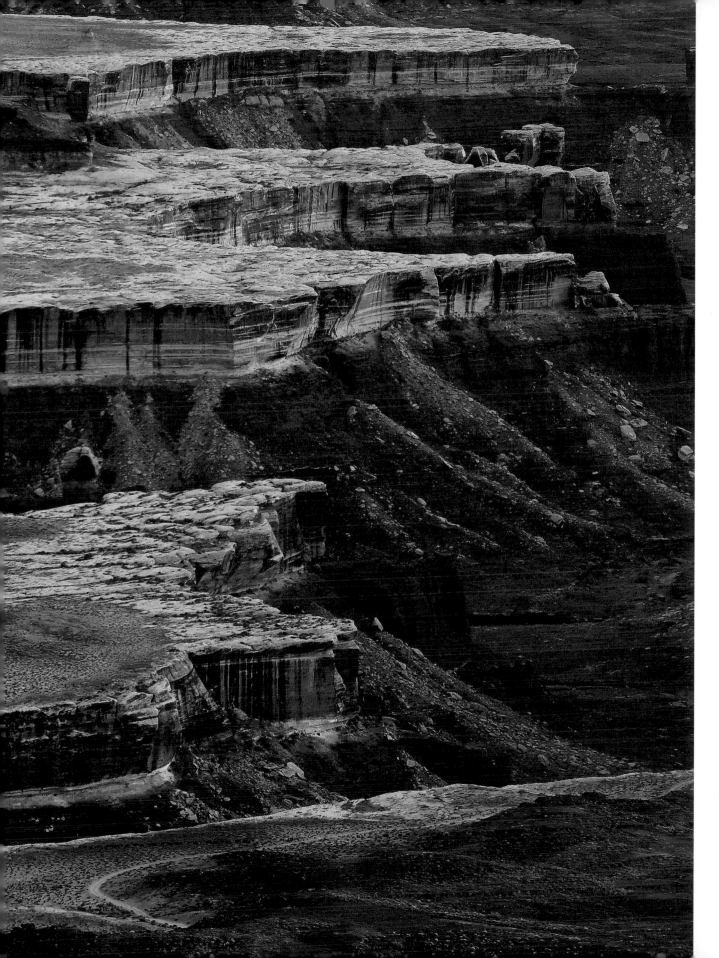

More than
375,000 people
visit Canyonlands
National Park each
year to witness its
dramatic landscapes.

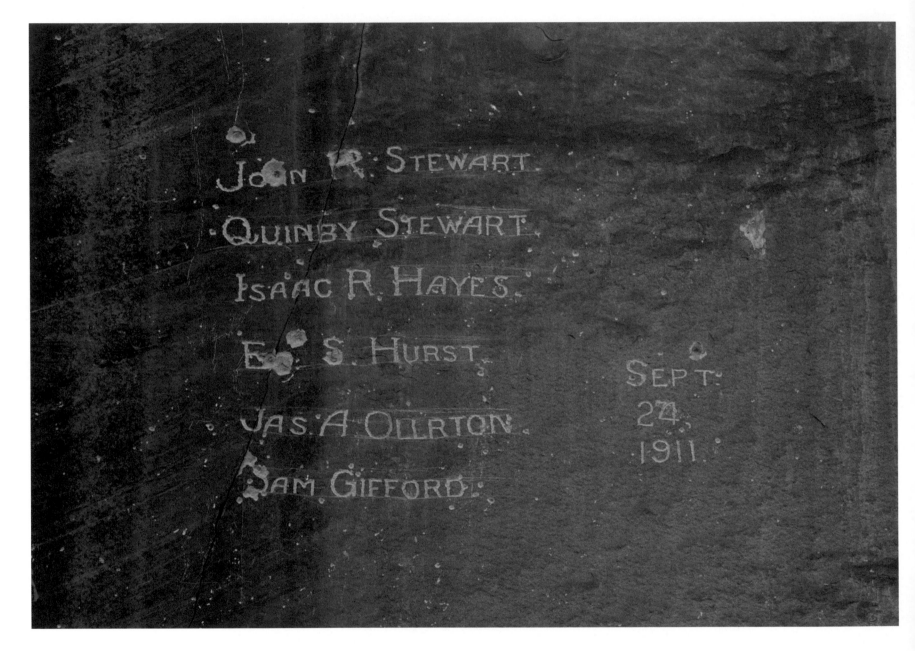

Early pioneer names are scratched into the cliff face of Capitol Reef National Park. Named after the dome-shaped rocks resembling the U.S. Capitol, the park is filled with unique sandstone formations and features a 100-mile-long bulge in the earth's surface.

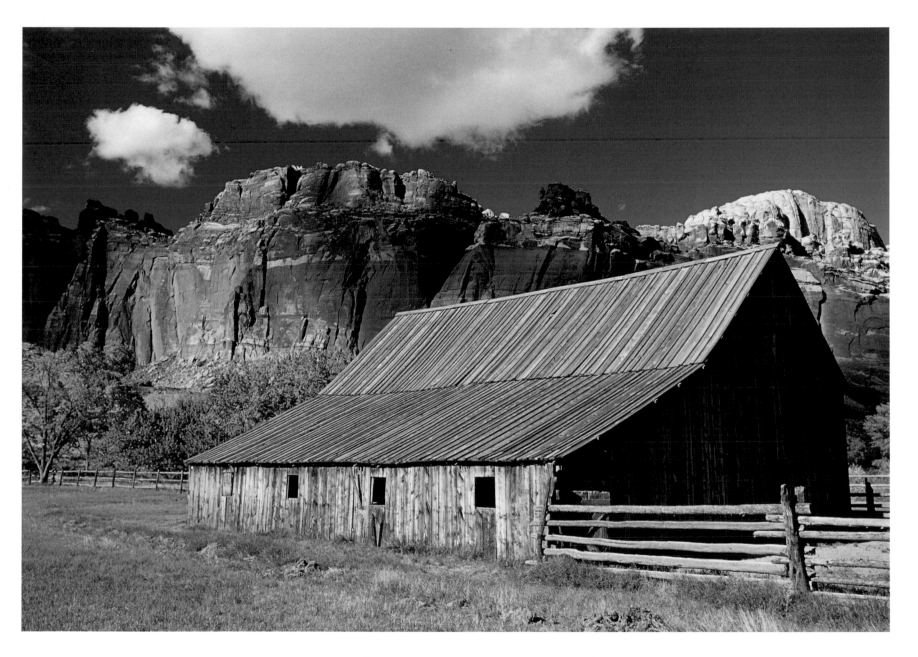

The Fruit Valley, a desert oasis filled with fruit trees, is located in Capitol Reef National Park. Its orchards and the Gifford Farm—remnants of the area's pioneer days—have been preserved to teach visitors about the homesteader's way of life.

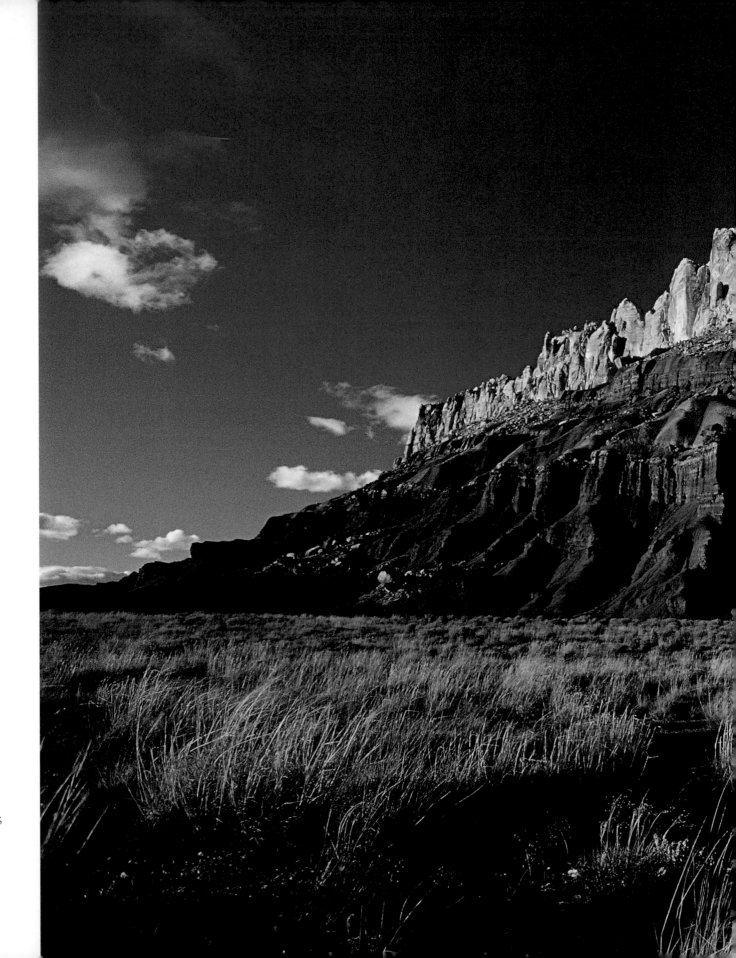

More than half a
million visitors a
year come to see
the natural wonders
of Capitol Reef's
241,904 acres.

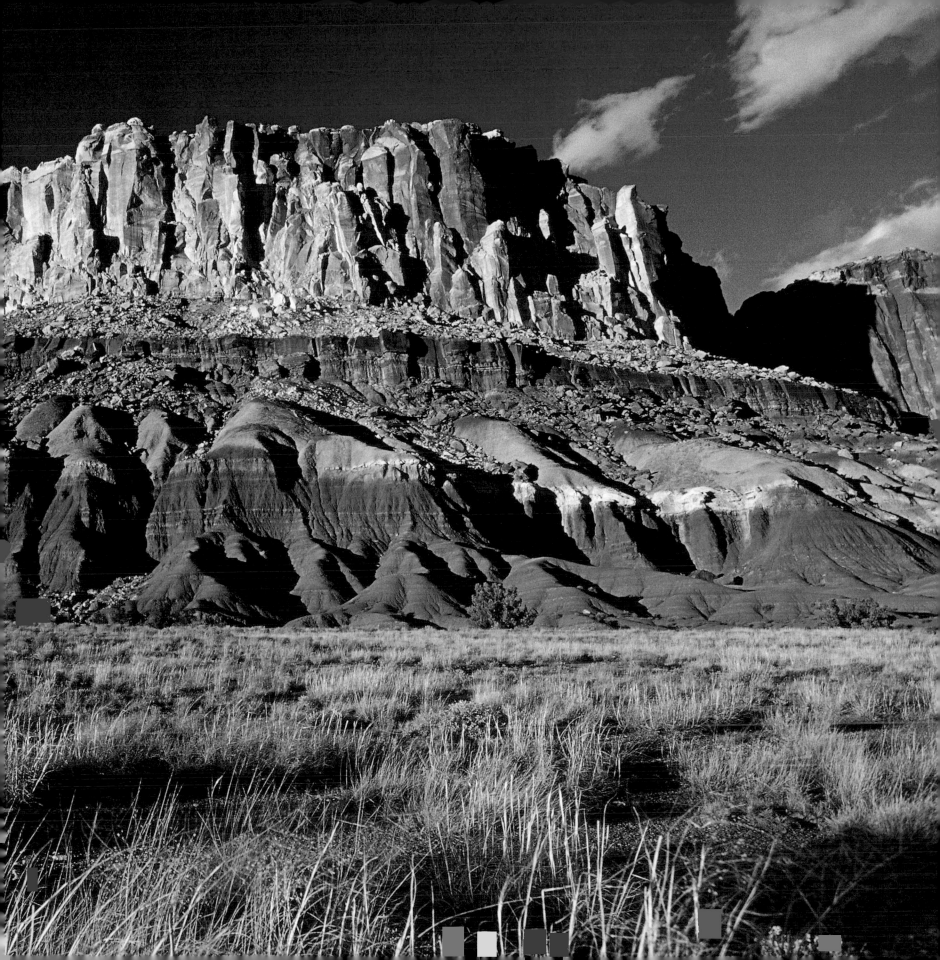

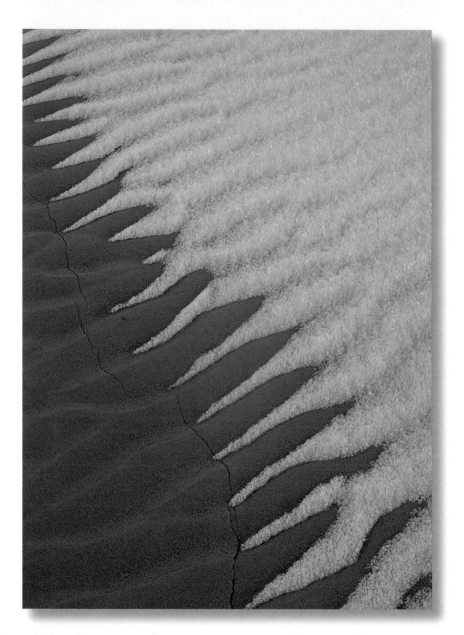

Utah's diverse landscapes—from mountains to barren deserts—create drastic changes in climate throughout the state. Fahrenheit temperatures range from below 0 in the winter to above 100 degrees in the summer.

One of the highlights of Capitol Reef National Park, the Hickman Bridge rises 125 feet above the ground and has a 130-foot span.

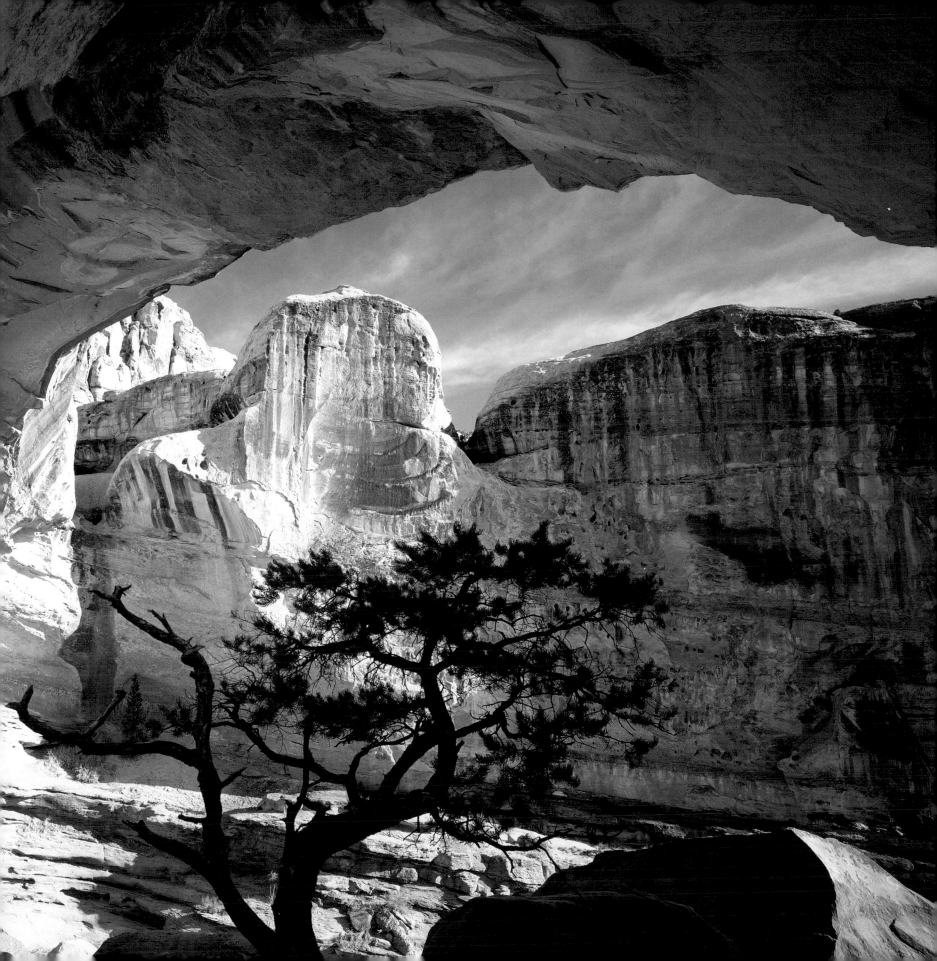

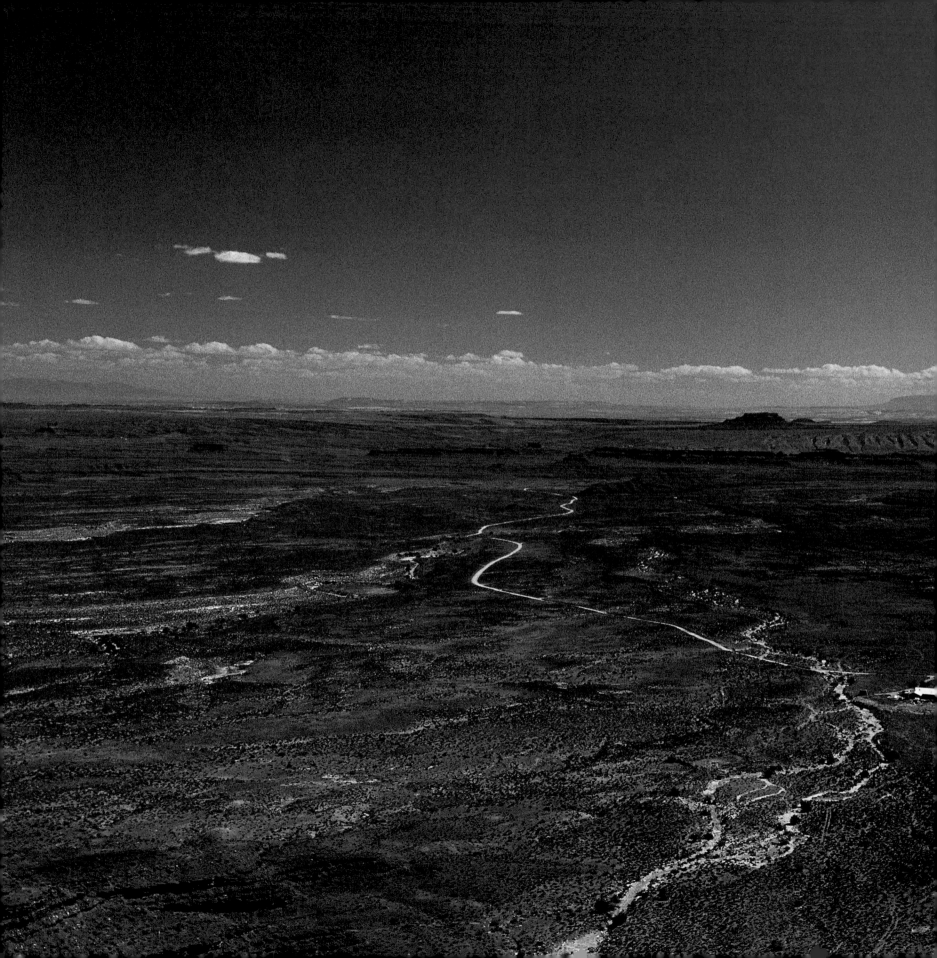

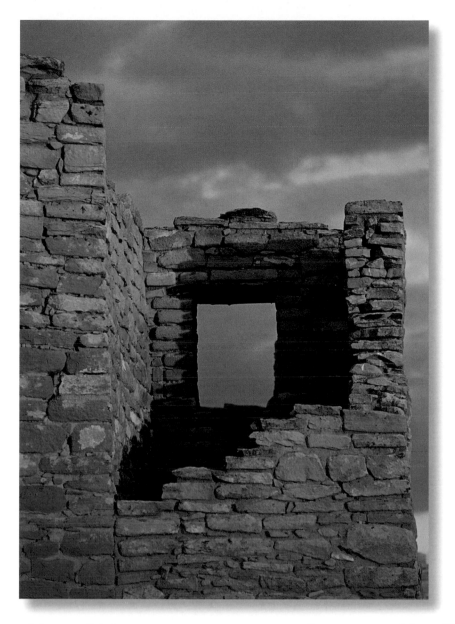

Hovenweep National Monument contains six prehistoric Pueblo villages. These villages contain multi-level buildings, balanced on boulders and canyon rims, that demonstrate the architectural mastery of their builders.

The 11th largest state in the U.S., Utah occupies 84,900 square miles. One of the four corner states, it borders Idaho, Wyoming, Colorado, New Mexico, Arizona, and Nevada.

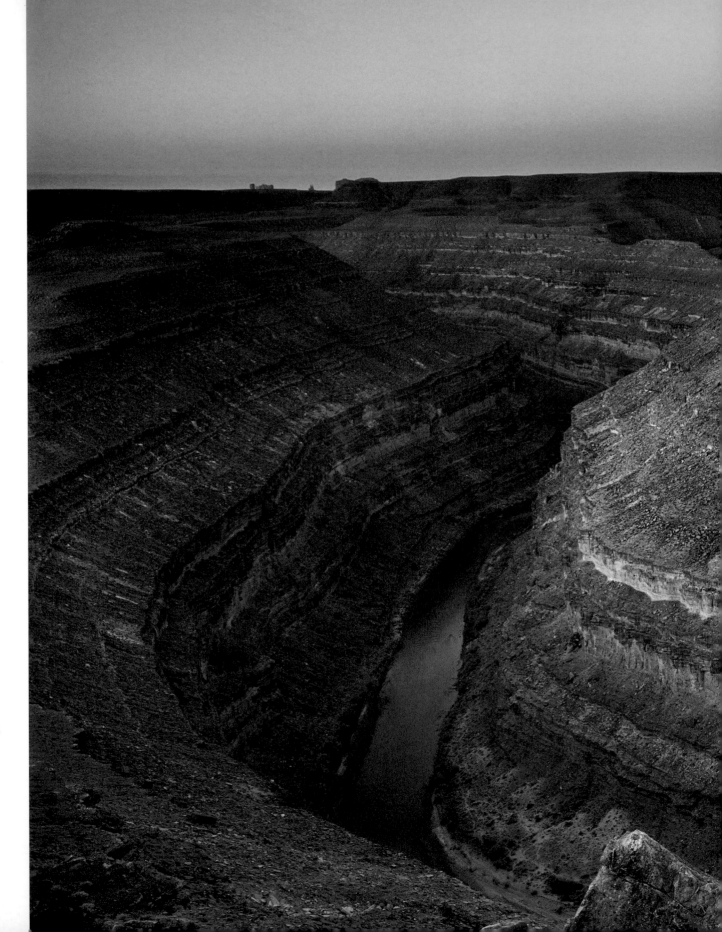

At Goosenecks State Park, visitors can look down a 1,000-foot chasm to the meandering San Juan River. Although the river weaves back and forth for five miles, it progresses only one mile.

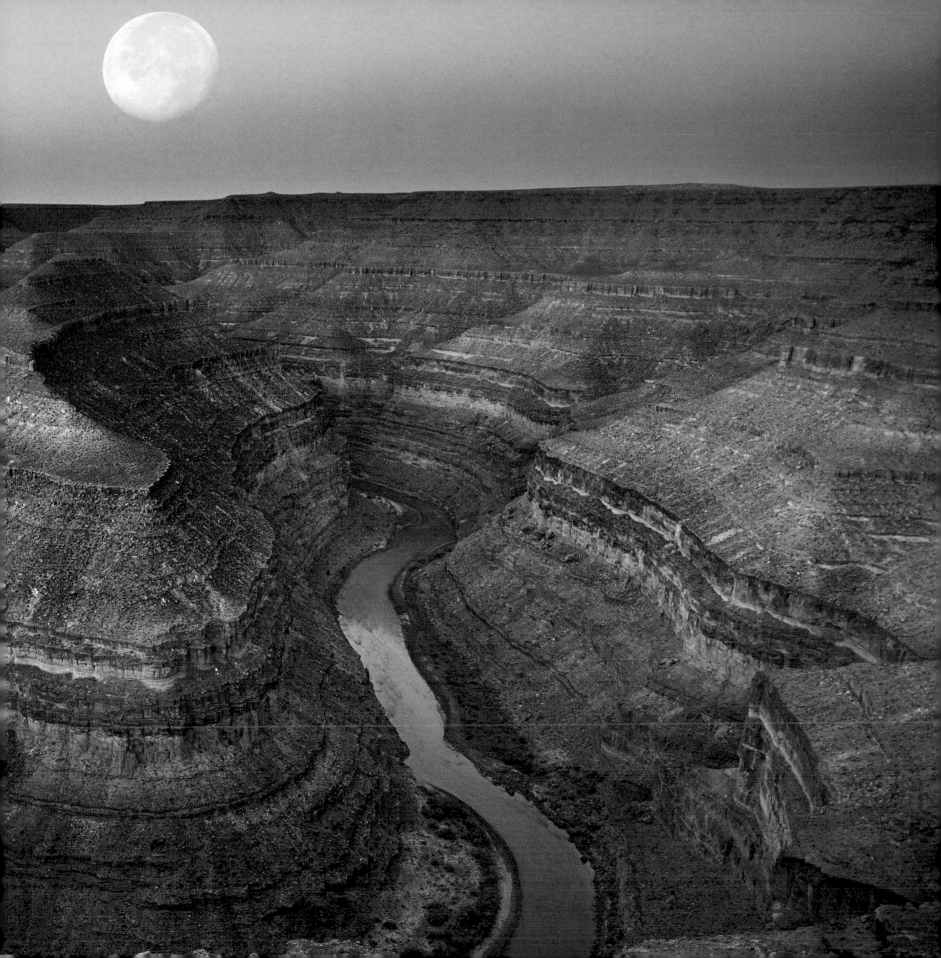

Visitors can experience more than 300 million years of geological history at Goosenecks State Park.

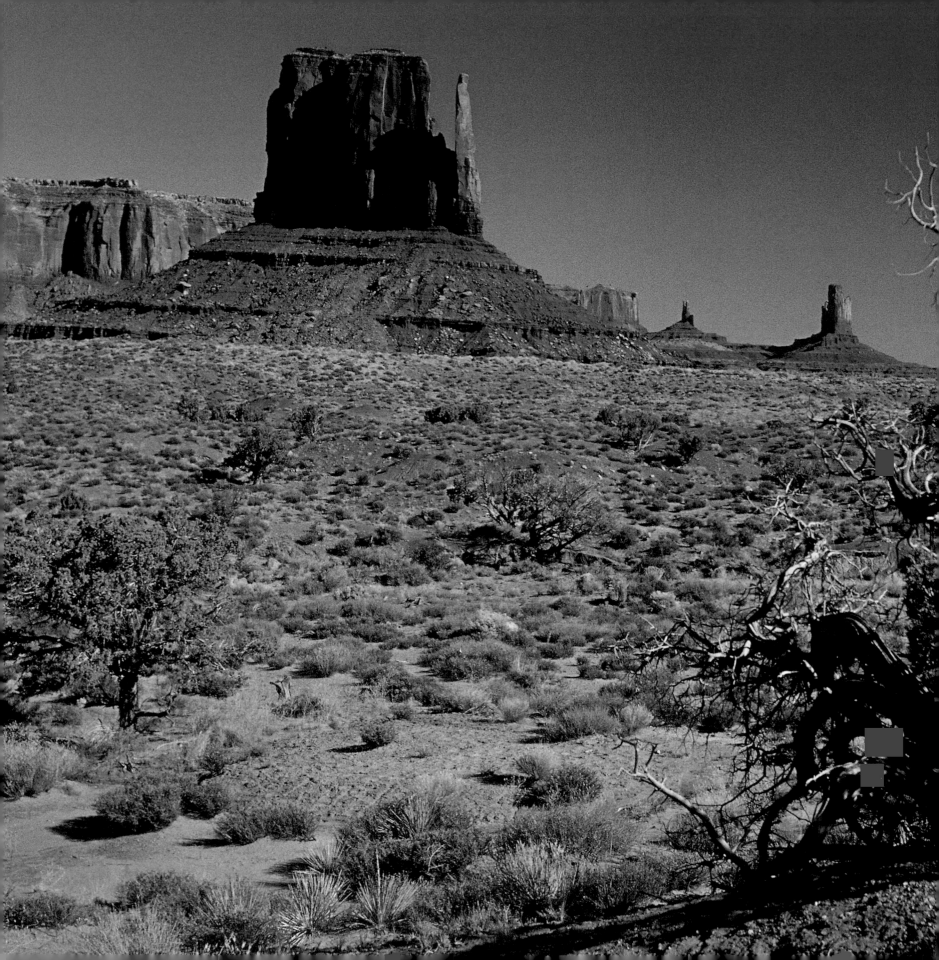

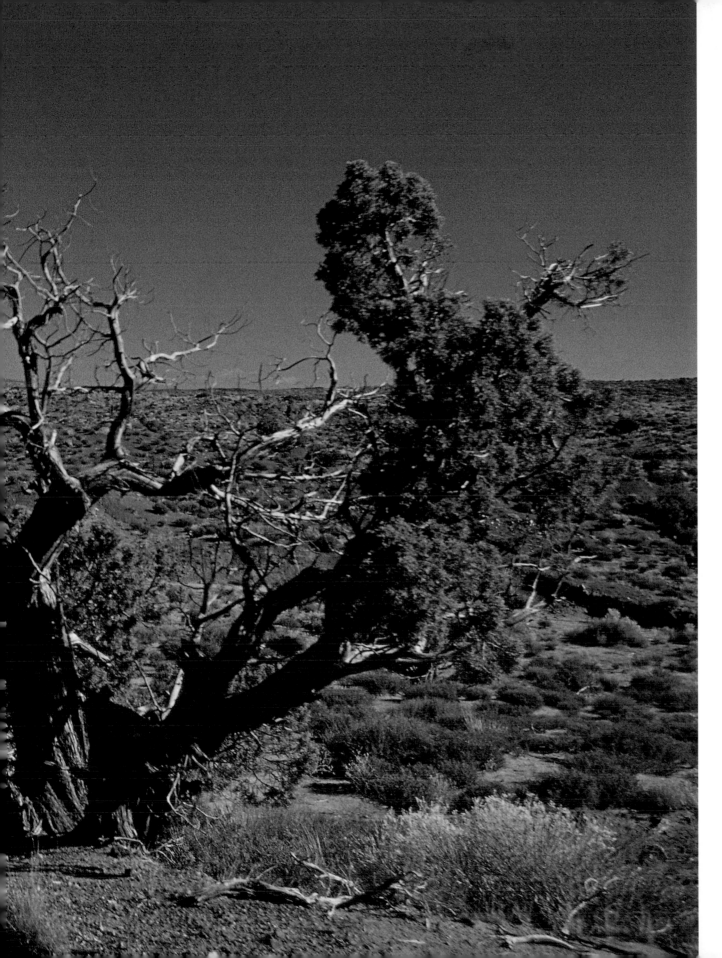

Free-standing rock formations rise up dramatically from the desert floor of Monument Valley. Up to 1,000 feet high, these mesas and buttes once formed part of a massive sandstone layer that slowly eroded over millions of years.

75

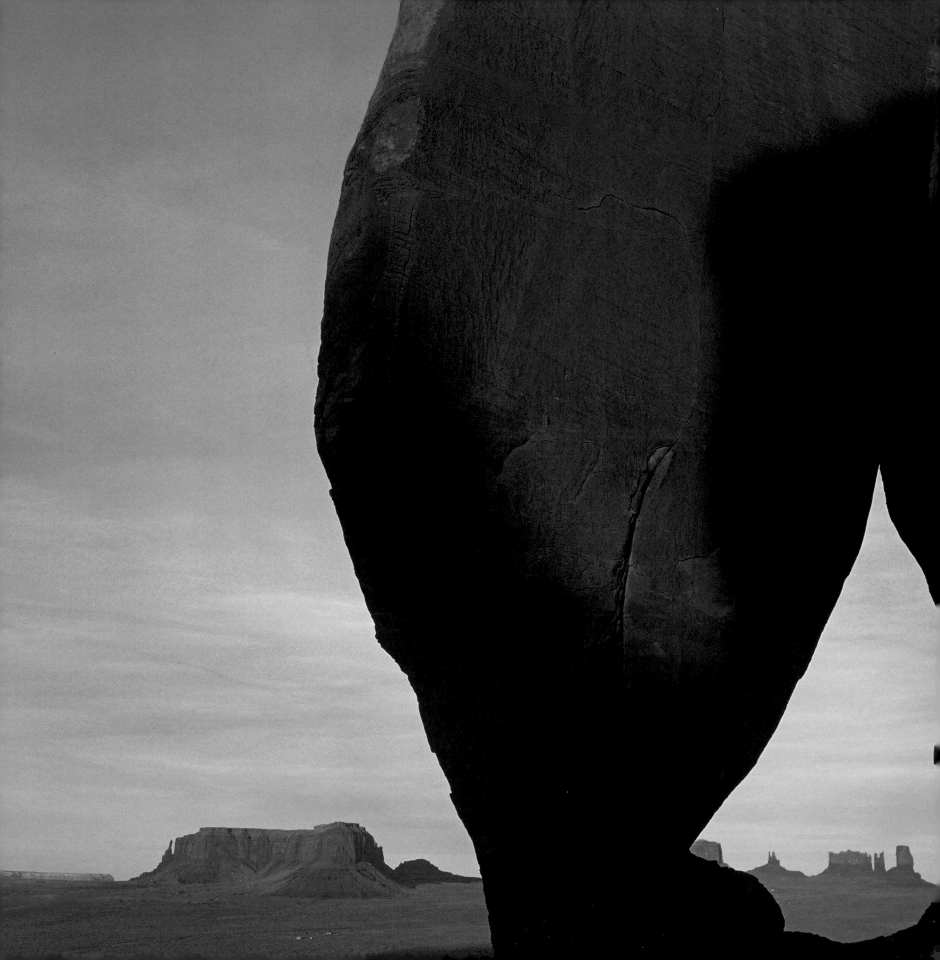

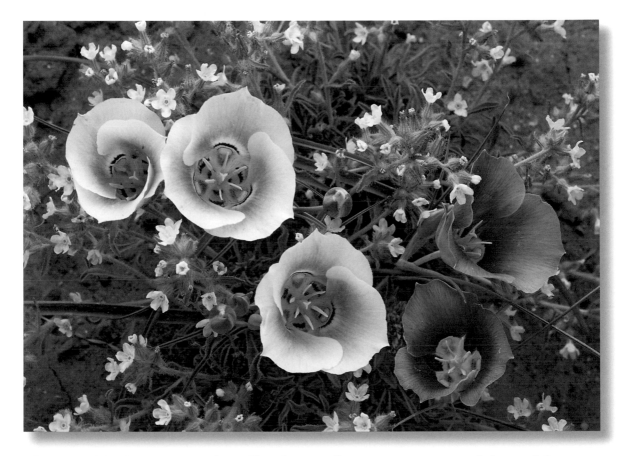

The sego lily became Utah's official state flower in 1911. Celebrated for their beauty, sego lilies were once an important food source. Early Mormon settlers ate the bulbs when food was scarce during their first Utah winter.

Vibrant multi-colored sandstone mesas and buttes form a stark contrast to the flat, sandy desert floor.

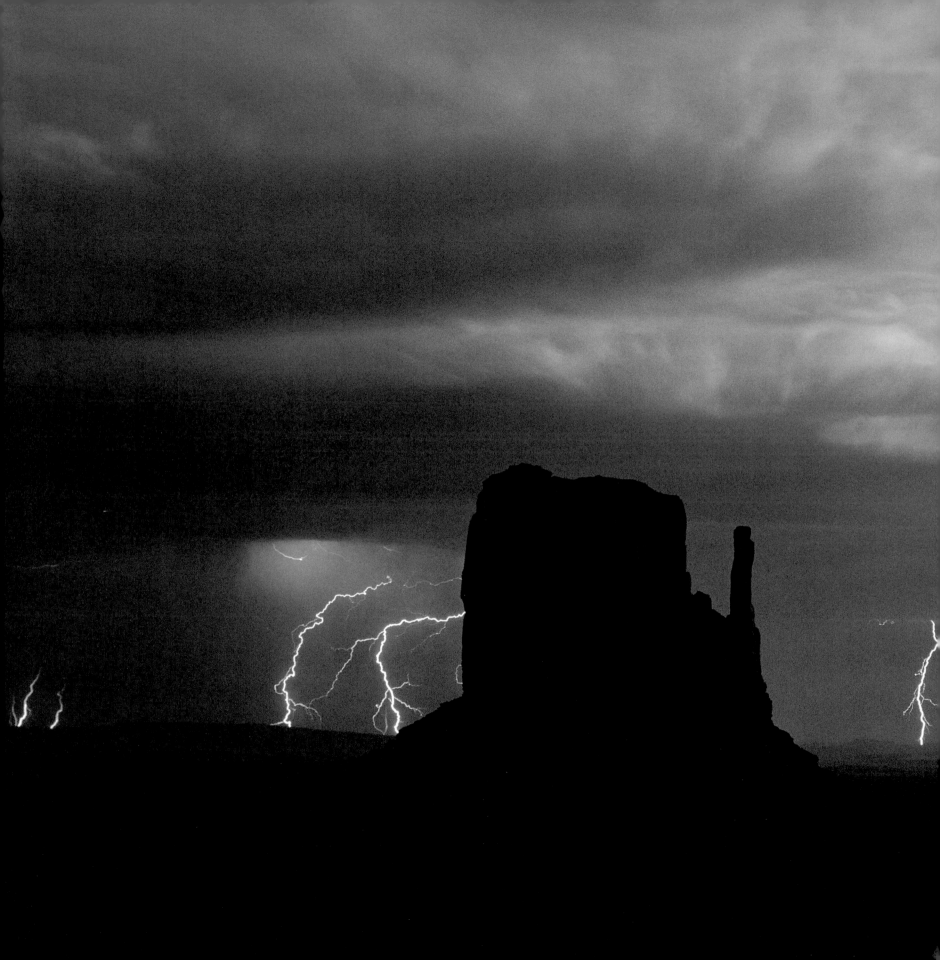

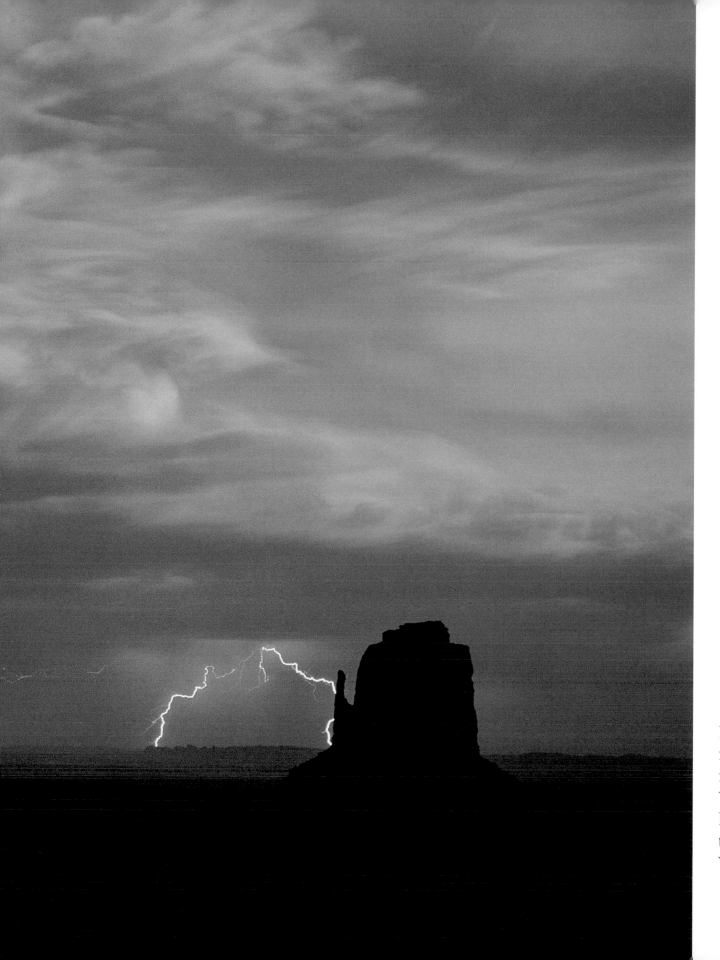

Many western
movies were filmed
in Monument Valley.
The dramatic, rugged
landscapes provide
the perfect Wild
West settings.

79

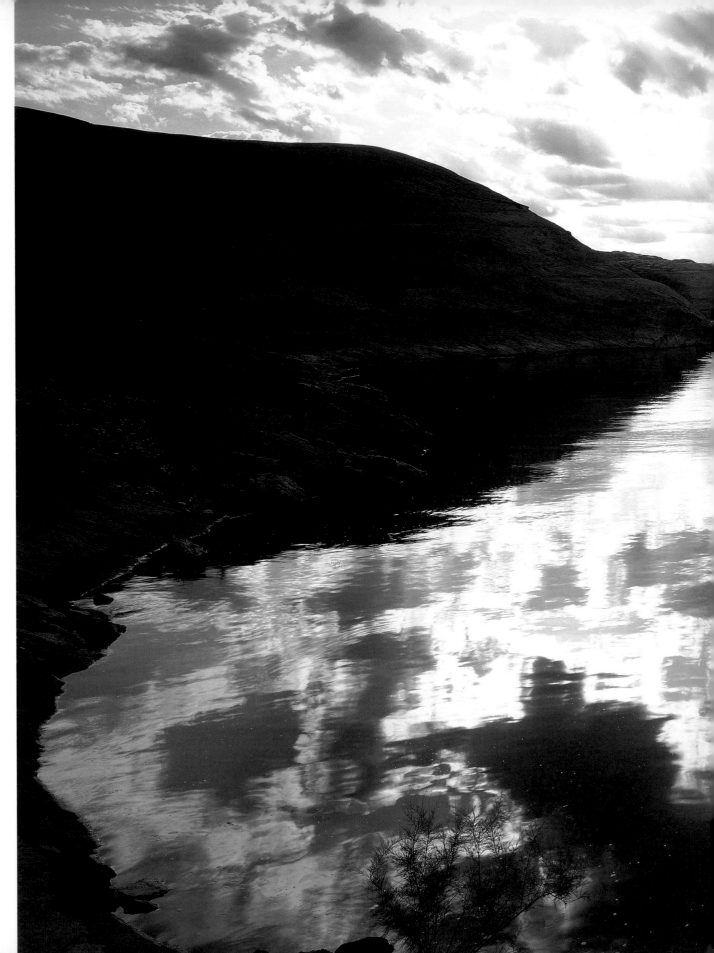

Often called "America's Natural Playground," Lake Powell is the second largest reservoir in North America. With almost 2,000 miles of shoreline, it's perfect for house-boating, fishing, and swimming.

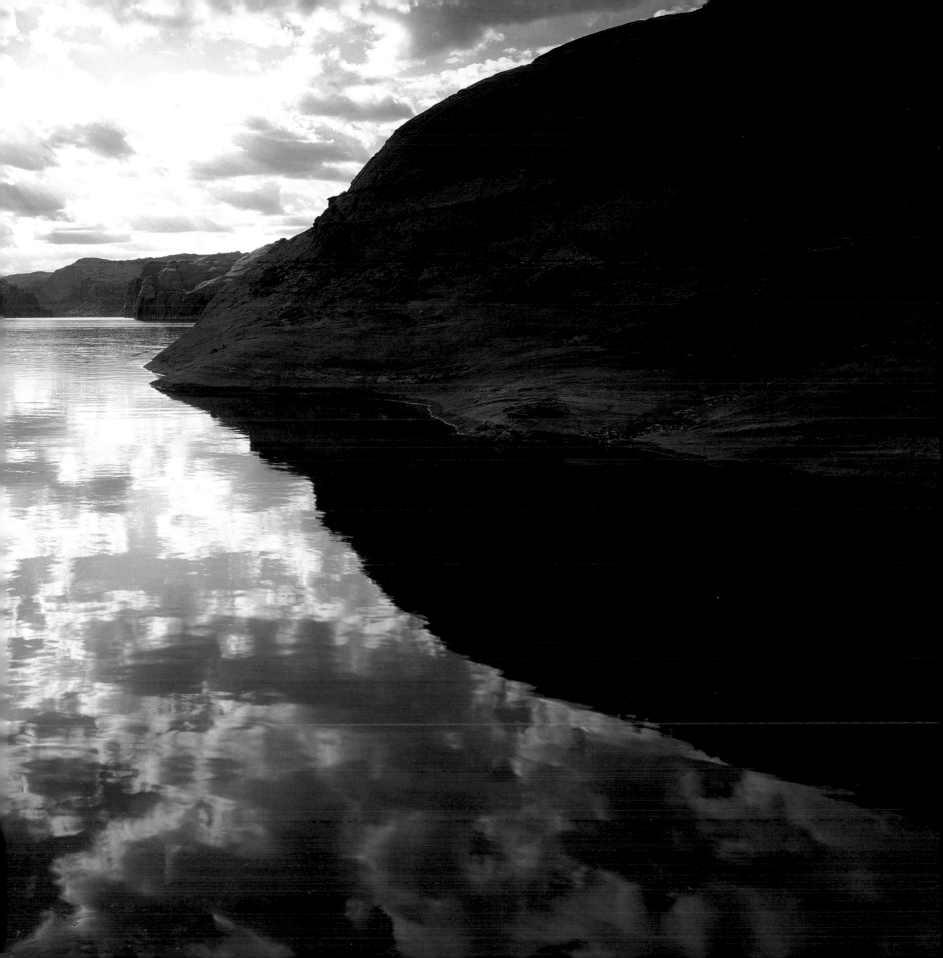

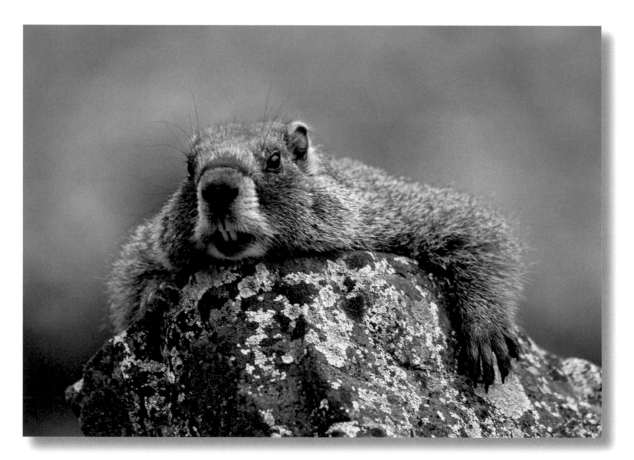

Yellow-bellied Marmots make their homes among boulder piles at the base of slopes. They can grow up to two feet long and live for up to 20 years.

Named for the natural staircase that climbs 5,000 feet to the rim of Bryce Canyon, Grand Staircase-Escalante National Monument is filled with a variety of dramatic multi-colored cliffs and canyons.

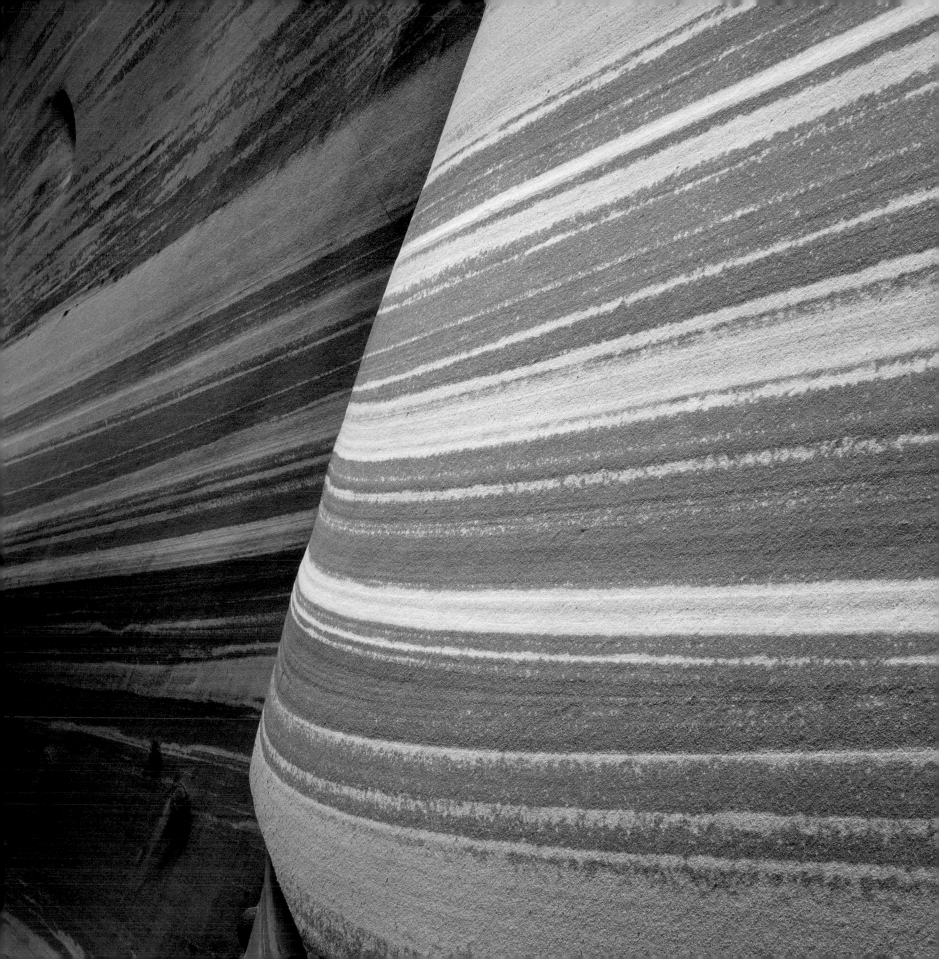

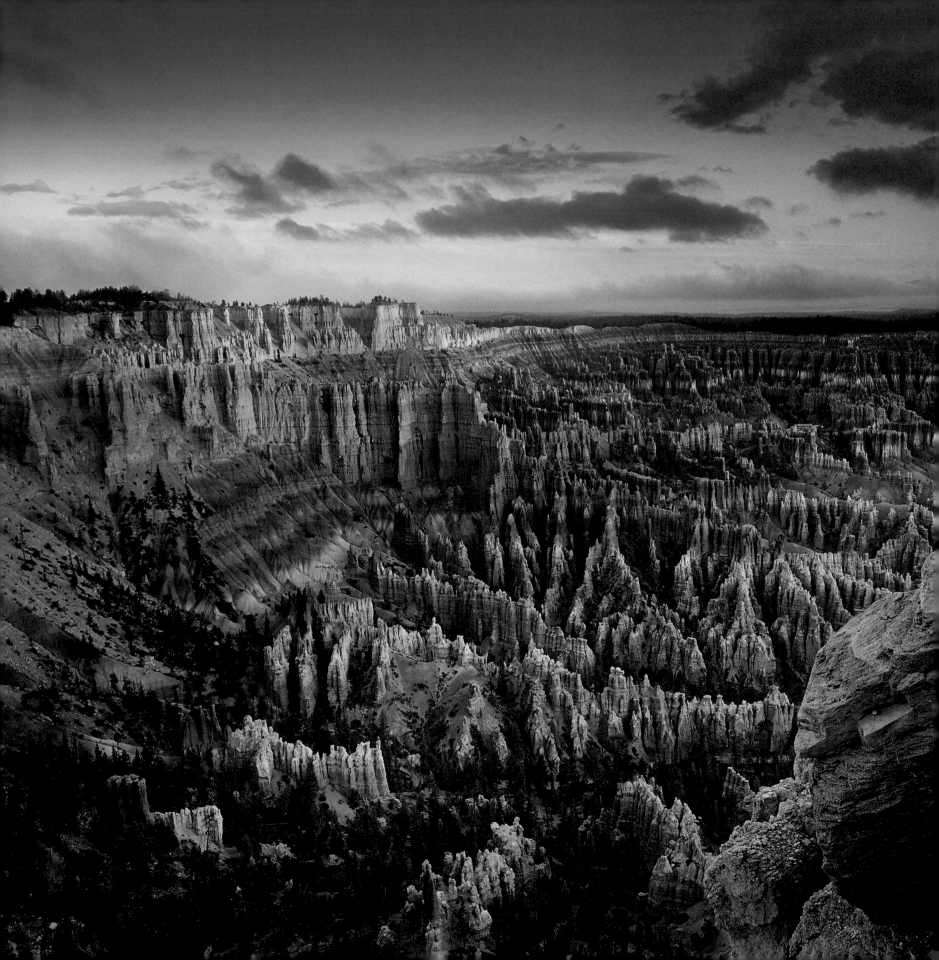

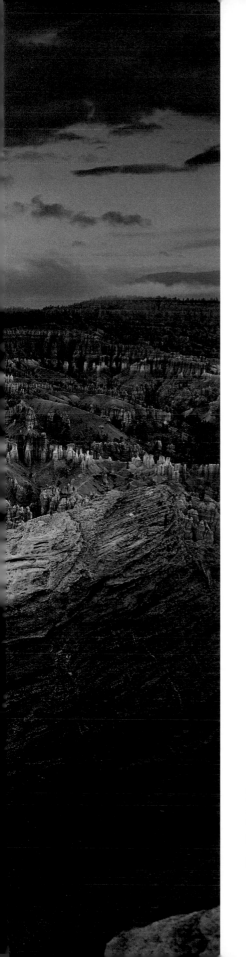

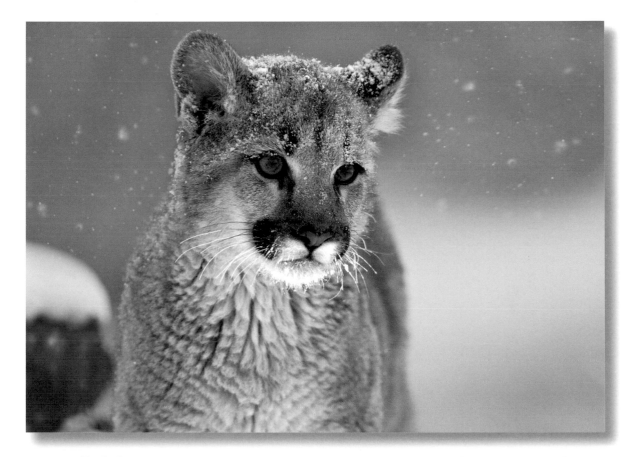

Also called the cougar, puma, panther, and painted cat, the mountain lion was once hunted almost to extinction in North America. These formidable creatures can run up to 30 miles an hour and jump up to 20 feet.

Named after Mormon pioneer Ebenezer Bryce, Bryce Canyon features dramatic horseshoe-shaped amphitheaters fashioned by nature from vibrant multi-hued rocks.

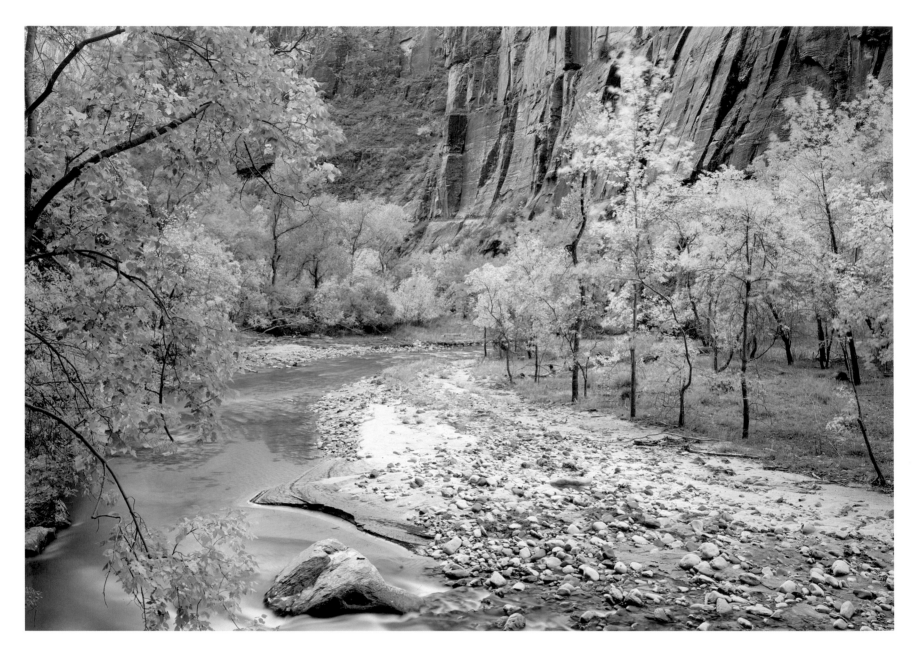

Named after the Hebrew word for sanctuary, Zion National Park protects more than 225 square miles of land.

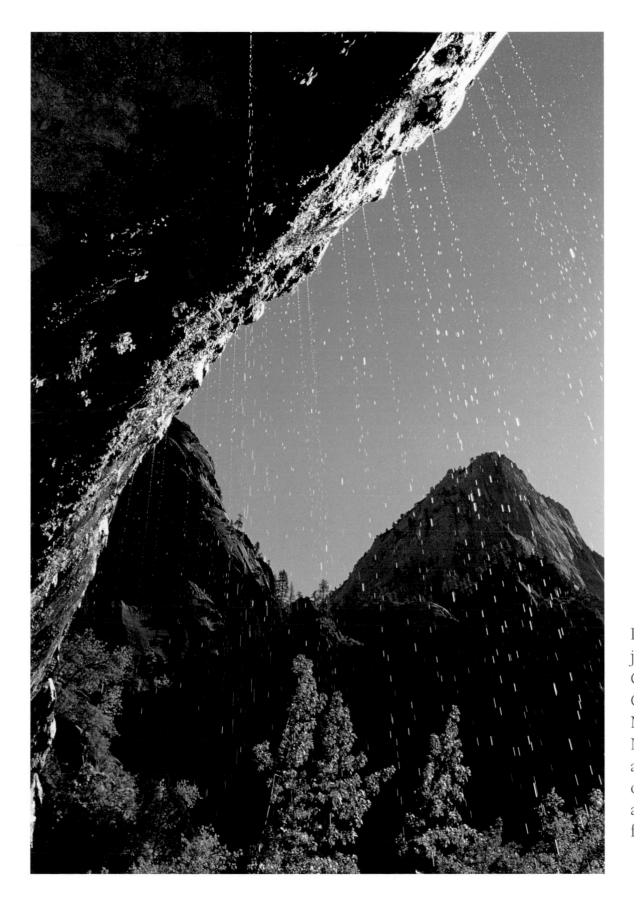

Located at the junction of the Colorado Plateau, Great Basin, and Mojave Desert, Zion National Park features a diverse collection of wildlife, plants, and geographical formations.

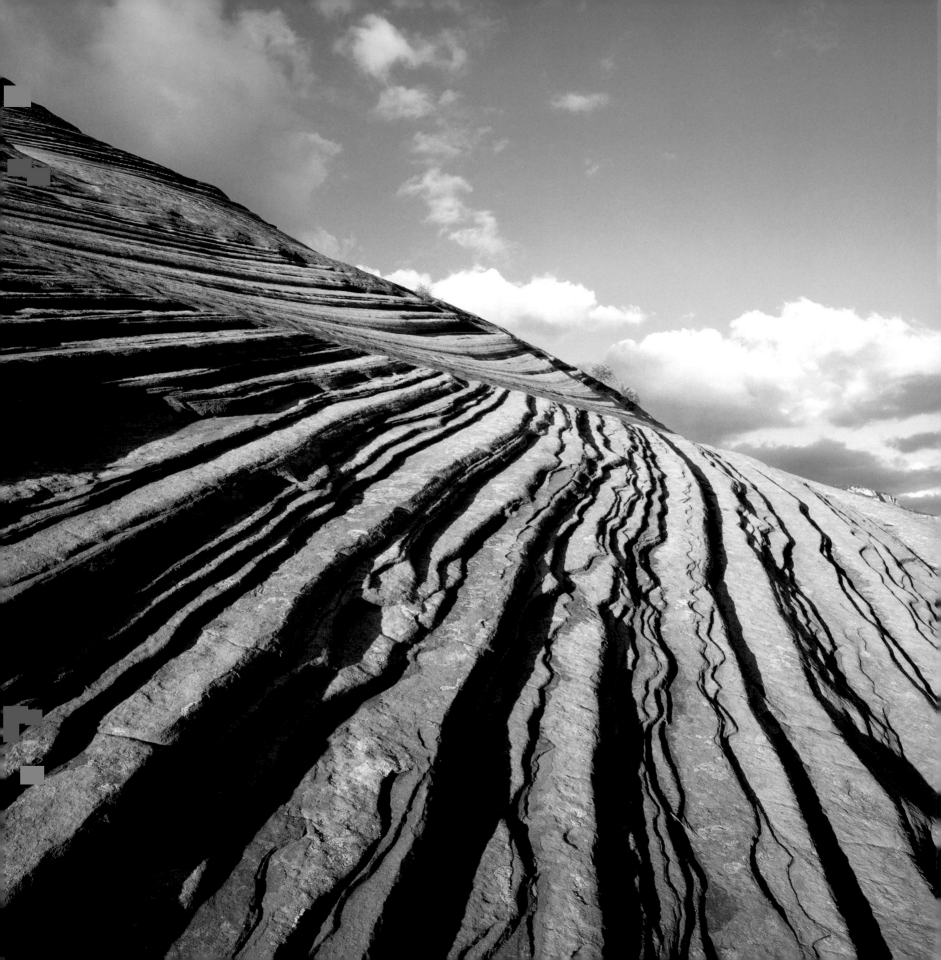

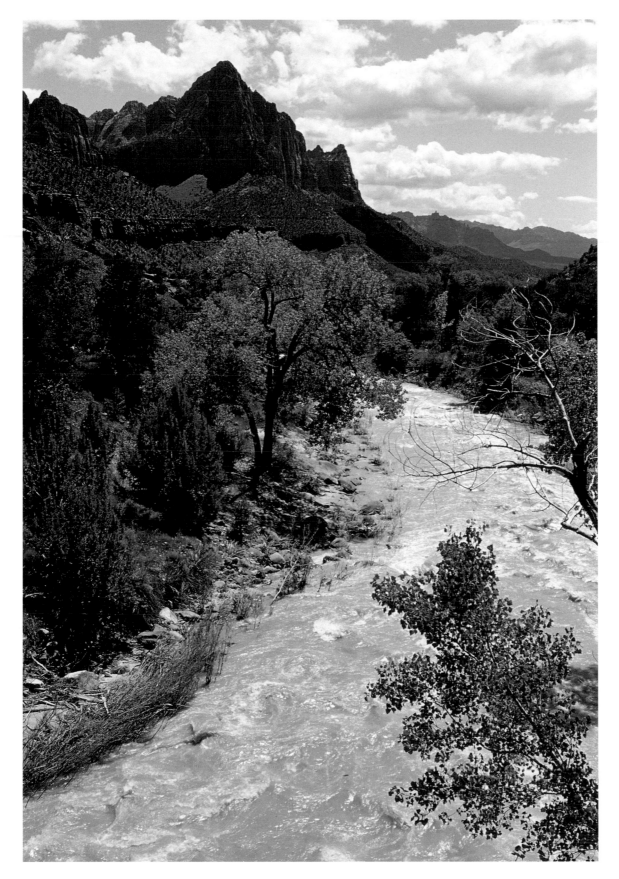

FACING PAGE
Zion National Park is
Utah's oldest national
park. Designated
in 1919, it attracts
almost 3 million
visitors a year.

Famous for its slot
canyons, monoliths,
and dramatic towers,
Zion National Park
is Utah's most popu-
lar national park,
drawing hikers and
visitors from all over
the world.

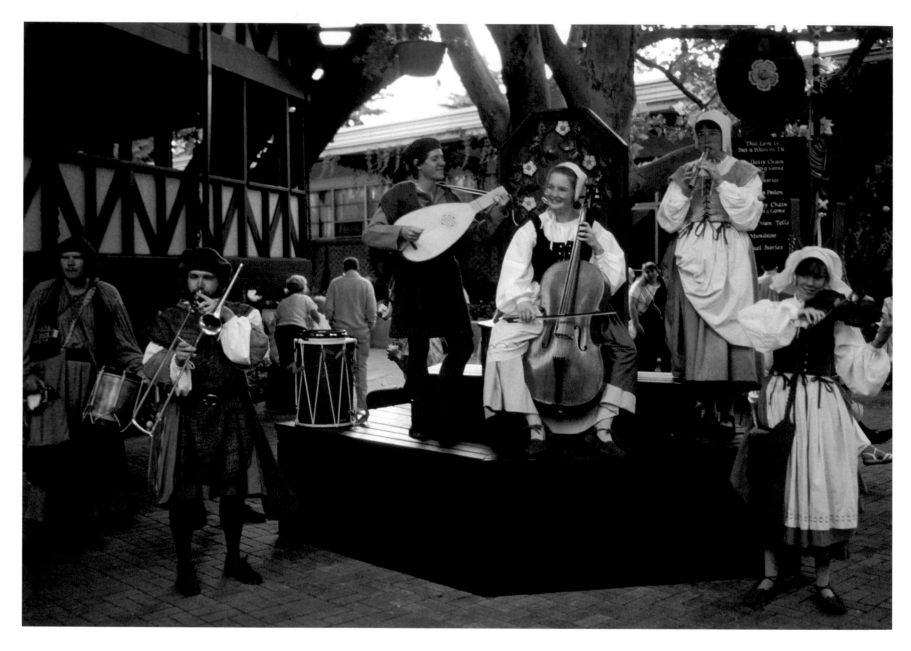

Each year, Cedar City attracts almost 150,000 people to its
Shakespeare Festival. Started in 1962, it's one of the country's
oldest and largest Shakespeare festivals.

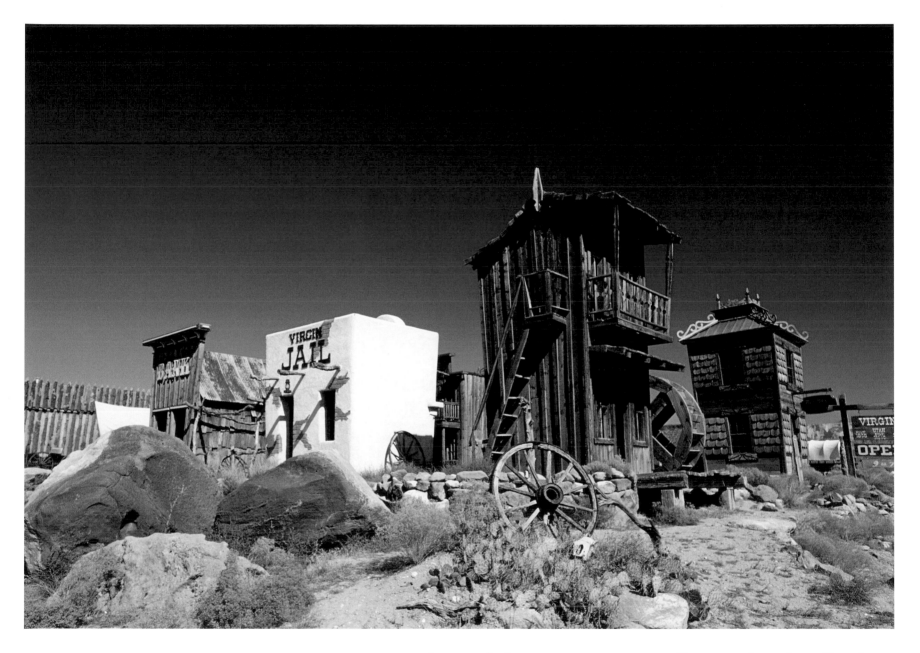

Pioneers first settled Virgin in 1857. Initially named Pocketville, the town soon took the name of the nearby Virgin River.

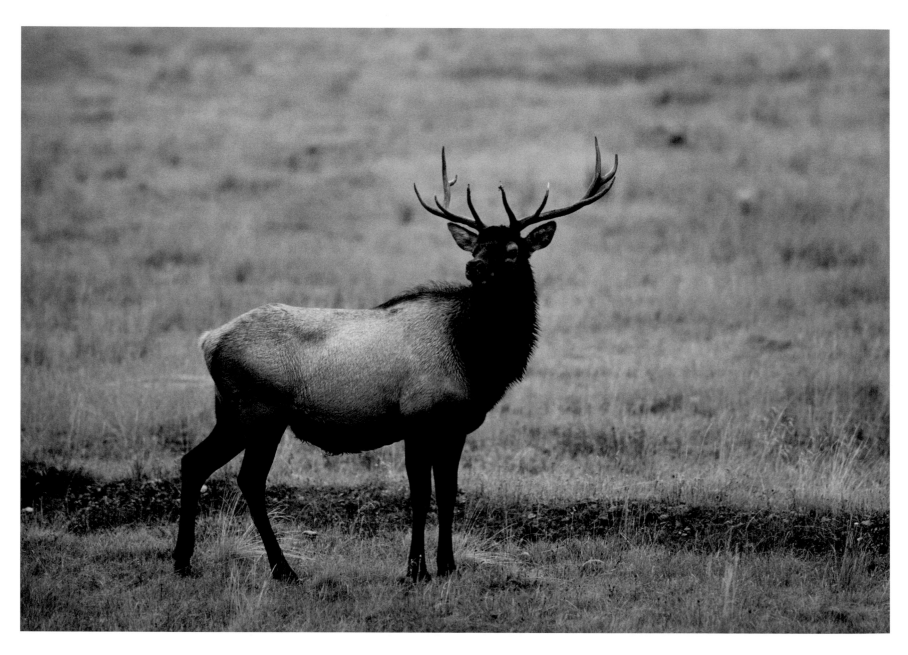

Populating the mountainous regions of Utah, the Rocky Mountain Elk became Utah's official state animal in 1971.

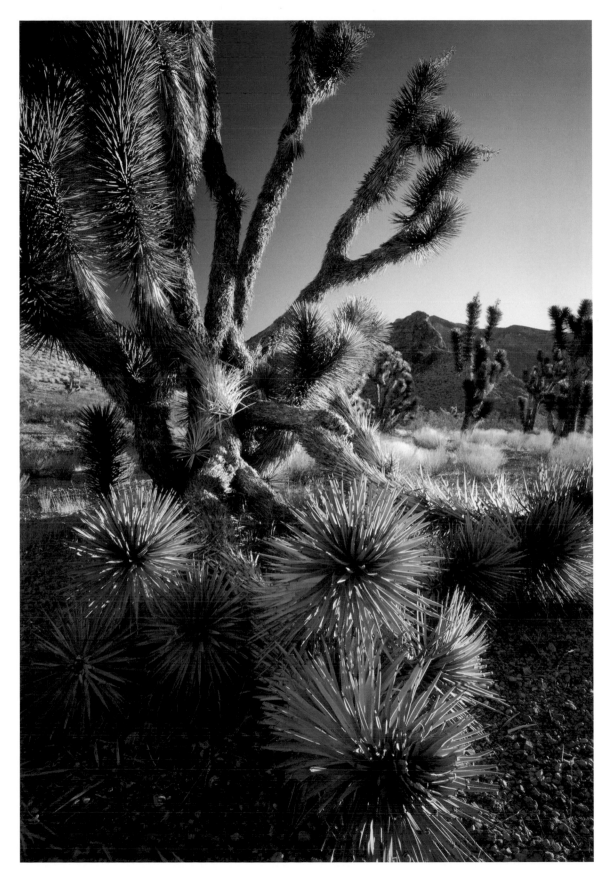

The northern reaches of the Mojave Desert extend into southern Utah. This distinctive ecosystem is home to the gnarled Joshua tree, a yucca that doesn't grow any-where else on earth.

OVERLEAF
Covering more than 3,700 acres, the salmon-colored sand dunes of Coral Pink Sand Dunes State Park are surrounded by red sandstone cliffs, brilliant blue skies, and thick pine forests.

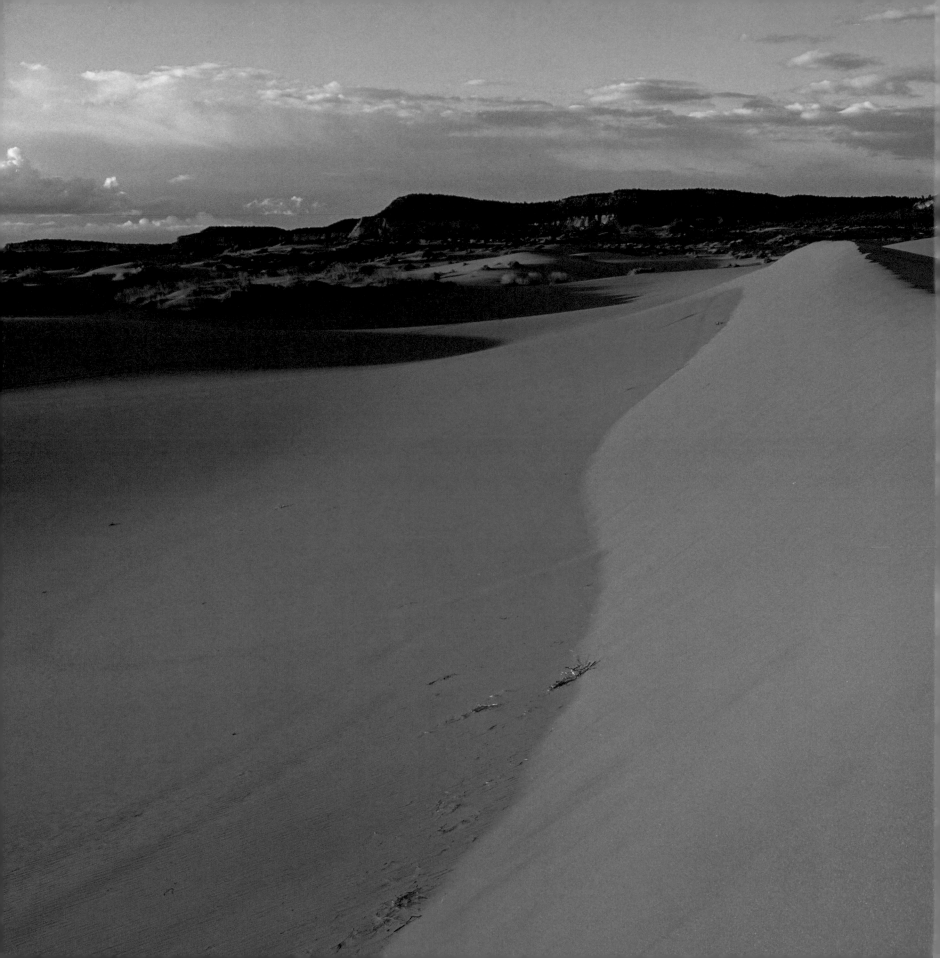

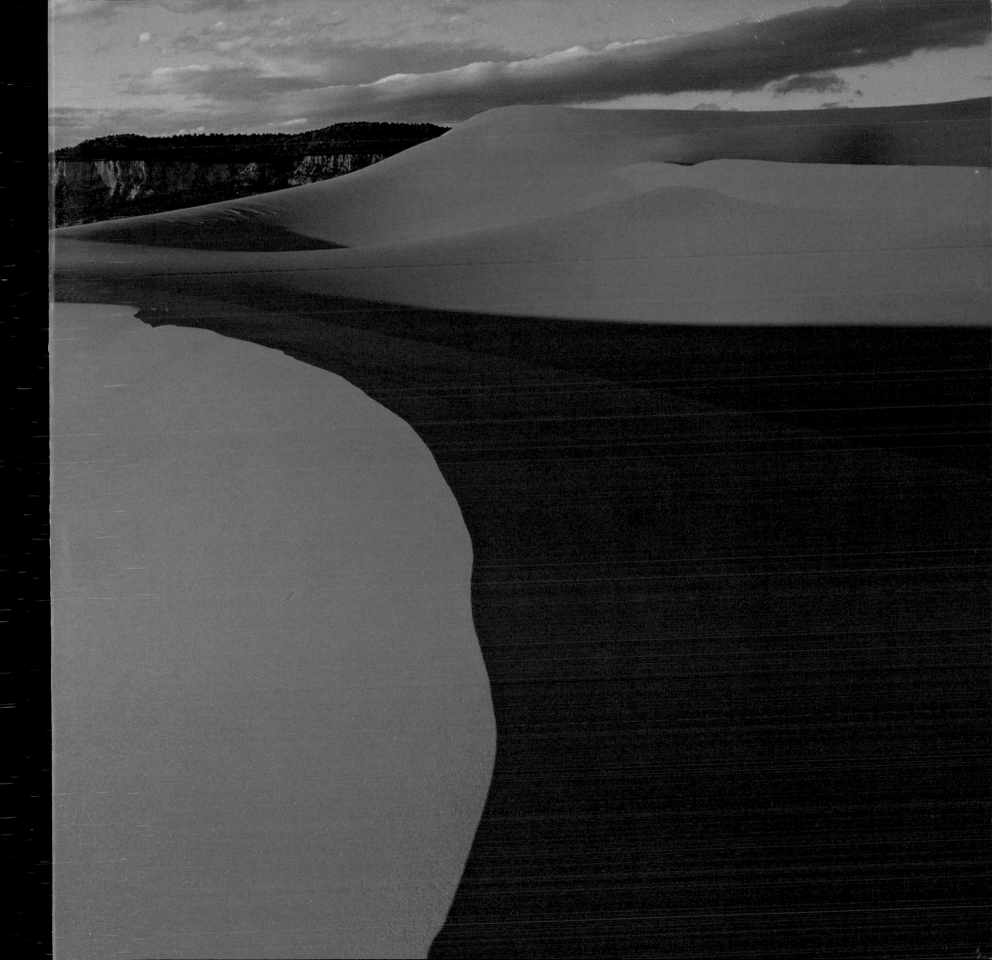